Focus On Food Photography for Bloggers

The *Focus On* Series

Photography is all about the end result—your photo. The *Focus On* series offers books with essential information so you can get the best photos without spending thousands of hours learning techniques or software skills. Each book focuses on a specific area of knowledge within photography, cutting through the often confusing waffle of photographic jargon to focus solely on showing you what you need to do to capture beautiful and dynamic shots every time you pick up your camera.

Titles in the *Focus On* series:

Focus On Food Photography for Bloggers

Focus on the Fundamentals

Matt Armendariz

Focal Press
Taylor & Francis Group

NEW YORK AND LONDON

First published 2013
by Focal Press
70 Blanchard Road, Suite 402, Burlington, MA 01803

Simultaneously published in the UK
by Focal Press
2 Park Square, Milton Park, Abingdon, Oxon OX14 4RN

Focal Press is an imprint of the Taylor & Francis Group, an informa business

Notices
Knowledge and best practice in this field are constantly changing. As new research and experience broaden our understanding, changes in research methods, professional practices, or medical treatment may become necessary.

Practitioners and researchers must always rely on their own experience and knowledge in evaluating and using any information, methods, compounds, or experiments described herein. In using such information or methods they should be mindful of their own safety and the safety of others, including parties for whom they have a professional responsibility.

Product or corporate names may be trademarks or registered trademarks, and are used only for identification and explanation without intent to infringe.

Library of Congress Cataloging-in-Publication Data
Armendariz, Matt.
 Focus on food photography for bloggers / Matt Armendariz.
 p. cm. — (Focus on the fundamentals)
 1. Photography of food. 2. Bloggs. I. Title. TR656.7.A76 2013
 778.9′96413—dc23
 2012023701

ISBN: 978-0-240-82367-6 (pbk)
ISBN: 978-0-240-82384-3 (ebk)

Typeset in Futura BT-Book
by TNQ Books and Journals, Chennai, India

Printed and bound in China by 1010 Printing International Ltd

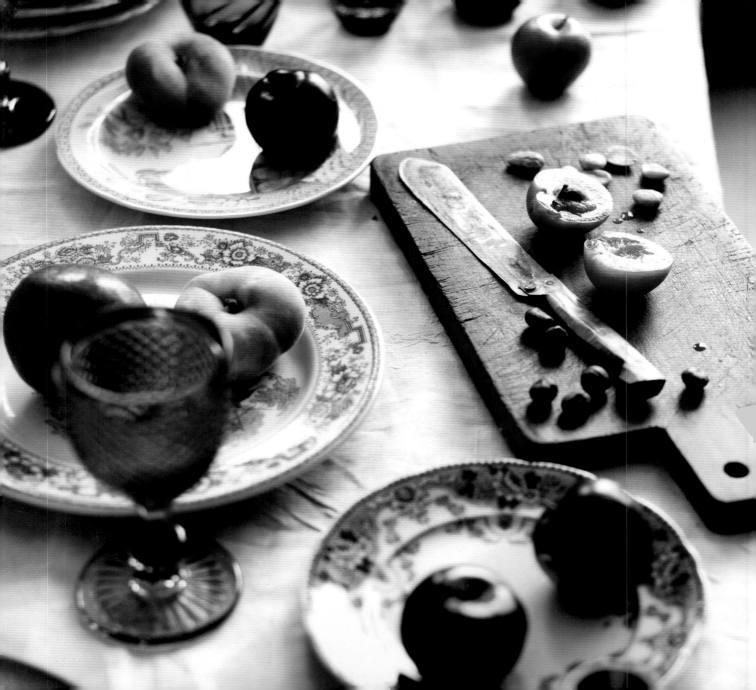

Contents

Introduction

I began blogging at the end of 2005 as a way to share my experiences of a career in food. At that time I was an art and advertising director in the food industry and found that many of the things I was doing didn't quite fit into the day job. What better way to share them than by starting a food blog? That's how www.mattbites.com was born. It also became an incubator for my burgeoning interest in food photography. At that point I wasn't a photographer, although I had spent years on photo sets, art directing and producing shoots and working with some amazing photographers. I felt as if all the pieces were there for me to jump into food photography. I just had to do it.

Fast forward to 2012. I've left the corporate world and entered the photography field full time and couldn't be happier. The visual medium is deeply satisfying to me and encompasses all the things I love: food, color, proportion, shape, storytelling, layout, and light. It allows me to work with amazingly creative people, producing photos for a variety of purposes: to tell a story, to sell something, to explain a process, to share a method—you name it, I've done it.

Of course, it hasn't always been easy. Photography is a very big world, and I am still learning. In fact, I don't think any of us ever stop learning when it comes to photography. It's certainly a process, not an end result, especially shooting something as ubiquitous as food. It's something we all share, something we're all an expert on (we each know what we like and dislike!), and it's something that connects us.

As you read this book, I want you to know that it is not meant as a comprehensive guide to the entire world of food photography. Yes, I've covered many of the best practices in shooting food that will apply to beginners and advanced folks alike, but all of what I cover is seen through the lens of the food blogger. There's no need for intimidation or fear if you're starting a food blog and photographing your own food, and I promise I won't confuse you with too many technical aspects either. Consider it a starting point, but remember this: employ many of the best practices seen in this book and they'll be things you carry with you throughout your photographic journey. I hope you enjoy every step of the way.

This book would not have been possible without the friendship and support of so many people: Alexis Hartman, Beryl Cohen, Brooke Burton, Carrie and Andrew Purcell, Cindie Flannigan, Dana Robinson, Dani Fisher, David Lebovitz, Denise Vivaldo, Eddie Vasquez, Gaby Dalkin, Helene Dujardin, Jeff and Susie Kauck, Jessica Goldman, Joe Randazzo, Joel Brown, Maggy Keet, Misha Gravenor, Nikolaos Misafiris, Ray Huerta, Thomas Dawson, Wade and Brittany Hammond, Wade Williams, and Paul Courtright.

I also want to thank Angela Fraser, Deb Puchalla, Caroline Allain, Jan DeLyser, Fabio

Fassone, Justin Schwartz, Leah Ross, Linsey Gallagher, Lisa Mattson, Lori Small, Marji Marrow, Mark Peel, Michelle Van Houten, Mory Thomas, Peter Barrett, and Todd Knoll.

To my editor, Stacey Walker, and the team at Focal Press, thank you a million times over. Stacey, what a joy it has been and your positivity is so awesome!

A very special thanks to Kristina Gill for everything you do.

And a super special thanks to Adam Pearson. This book (or me!) could not exist without you.

And to my parents, Ben and Helen, for always believing in me, especially when I was building sets in my bedroom at age seven. You are my world.

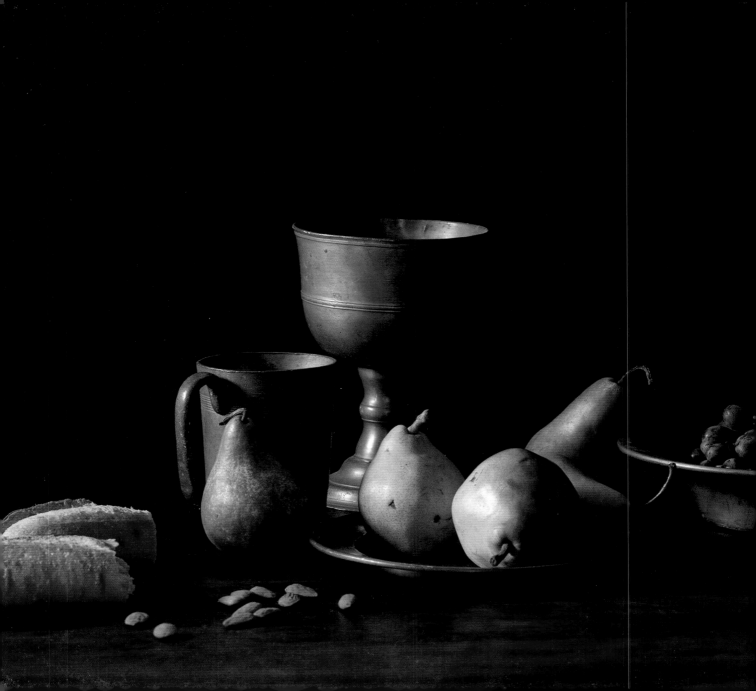

PART 1: THE NUTS AND BOLTS
Chapter 1: A Brief History of Food Photography

My ode to a still-life food painting, shot digitally.

For thousands of years, people have been documenting their food through art. The ancient Romans painted beautiful still-life images while artists throughout centuries have been painting markets, hunts, and religious ceremonies all centered around food.

The invention of photography changed the way people looked at food. No longer only painted in oils on canvas or sketched with pen and ink, food began to appear in photographs at the beginning of the 19th century. As reported by the *New York Times,* the first reported photograph of food was created by Joseph Nicéphore Niépce in 1832. His black-and-white still life of a bowl, bread, and goblet set the stage for a new world of food images.

Fast forward to the 1930s and 1940s. Commercial color food photography was utilized in advertising and publishing, with many photographers pioneering the way we look at food. In a sense, you could say this began the era of food photography as we know it, with food images appearing in cookbooks and magazines, on packages and posters. This doesn't mean that food photography hasn't changed in 80 years, though; aesthetics, styling, and technology have made sure of that.

The world of food photography went through two big recent shifts: the first was the advent of digital photography for professional photographers, and the second was food blogging and affordable digital cameras. The result has been an explosion of food images, both online via blogs and food sites as well as in print through books and magazines. At no point in history have we looked at more images of food and

drink as we are looking at now, and I happen to think it's exhilarating!

And when we look at some quick numbers (yes, there are thousands and thousands of food blogs out there, although finding an exact number is difficult), it's easy to see that food blogging is here to stay.

And considering you eat with your eyes first, photography for food blogs isn't an afterthought. It's a way to share our hearts and our kitchens with the world.

In a nutshell, I'm defining food photography as the process of creating images of food—and drink, too! It's a liberal term that includes photos of restaurants, people cooking, ingredients, kitchens, finished plates, raw food, still life, in a studio, out of a studio—wherever food is made, prepared, consumed, and enjoyed. I'll make sure to differentiate the style of food photography when necessary.

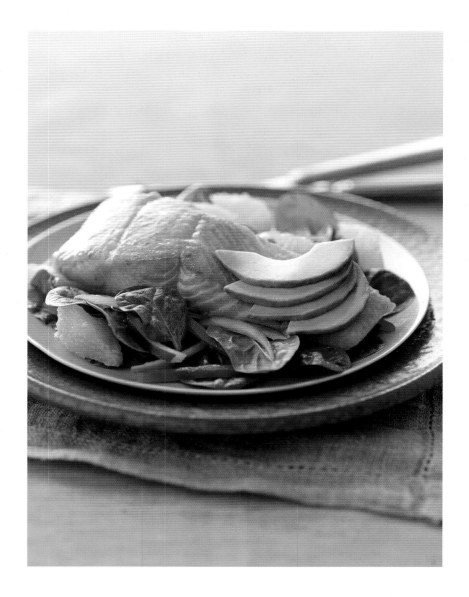

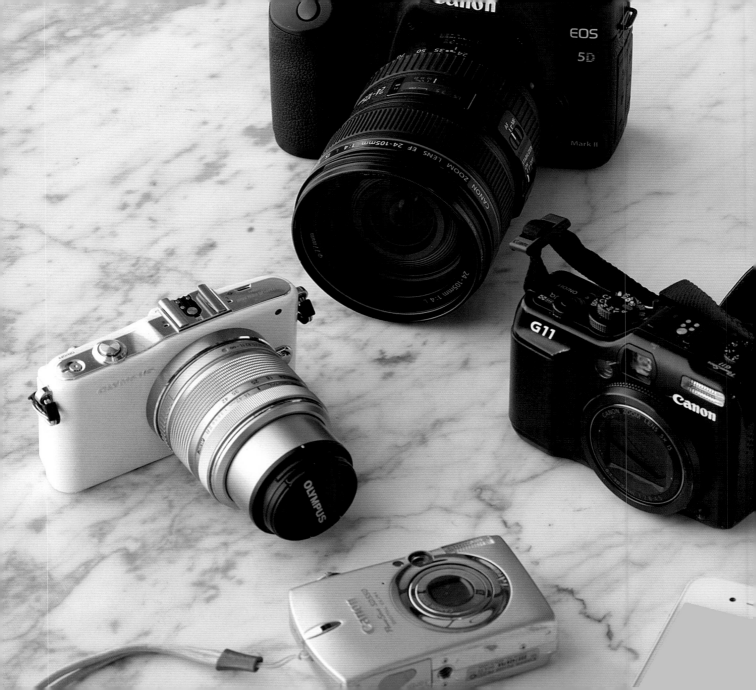

Chapter 2: Lenses, Cameras, and File Types

A collection of various cameras—certainly not a comprehensive visual, as there are so many varieties!

Before jumping into this chapter, I'll answer the question you might be thinking right now:

"Which camera should I use?"

I only start off this chapter with this because it's probably the question I get asked the most when discussing food photography.

And my response?

"The one that works for you."

Okay, I know that sounds like a cop out, but it's really not. It's just that the question is much like asking me which kind of car you should drive. Where is it you want to go? Will you be driving on freeways or city streets primarily? Will you need to drive off road on ice

towing a snowmobile? How many passengers will be with you? Do you like minivans or sports cars? Do you like all the bells and whistles or just the basics? Satellite radio? A navigation system? Traction control? All-wheel drive? Parking assist? The newest, hottest model or an old beater? Because really, any car can get you from point A to point B, it just depends on how you want to get there and what challenges you might face.

I'm making the comparison between camera type and car model because it all comes down to this: What are your needs? Although we are talking about pictures here, there are a million and one ways to go about the same thing when it comes to photography.

Identifying what type of food photography you'll be making will help identify your equipment needs. Taking close-ups of tiny intricate candies? You'll need a camera with a macro feature. Photographing expansive dining rooms as you travel the world? A wide-angle lens might be right for you. Getting down 'n' dirty and only want some quick snapshots of dinner before you gobble it down? A simple point-and-shoot (or your phone) will work. Again, figuring out your needs helps you make a wise decision when purchasing a camera. Your wallet will thank you.

A quick primer

I won't be addressing film cameras in this book, although the same best practices for shooting food would apply to almost any camera. For the sake of discussion, I will be referring to digital only.

Point-and-Shoot (Compact)

A point-and-shoot camera is most likely what folks think of when discussing automatic cameras. They're compact, relatively simple to use, and run the gamut from fully automatic to having more advanced features like the ability to shoot RAW files. Available in a variety of price points, these cameras are geared for simple point and shooting moments, hence the name. They tend to have smaller sensors inside which makes for smaller file size and less dynamic images.

PROS: Inexpensive, easy to carry around and sneak into the latest, hottest restaurant. CONS: You sometimes sacrifice functionality and features for the price and size. You can't change lenses.

dSLR

dSLR stands for digital single-lens reflex. It's a camera system that uses a mirror system and pentaprism to capture an image on its sensor. The mirror reflects the image into the viewfinder, and when you're ready to create your image it flips up to allow the light to pass to the camera sensor. All this is fancy talk for most medium-level cameras that can be fully manual and allow you to change lenses, something very important. But it's not everything!

PROS: Extremely customizable, usually the highest pixel count, allows you to change lenses depending on your needs.
CONS: Can be the most expensive. Also the largest style of camera, lens included. Sometimes heavy.

Micro Four Thirds (MFT)

A micro four thirds camera is a relatively new invention from Panasonic and Olympus that lives between a compact point-and-shoot and a dSLR camera. The main distinguishing feature is that the manufacturers have done away with the mirror system seen in dSLR cameras, yet these cameras retain the ability to use interchangeable lenses. They are smaller with larger sensors than the standard point-and-shoot cameras.

PROS: Extremely small with high-quality sensors. Ability to change lenses.
CONS: Not quite all the same features as a dSLR, but that's not really a bad thing, is it? Also at this current time they're a relatively new format.

Cell Phone

Most cell phones these days have a built-in camera. They're usually the most basic of digital cameras and don't allow you to control the shutter or focus. However, they're great in the fact that they offer immediacy and ease. We're always on our phones, right? Why are you looking at me that way?

PROS: You always have it with you and they're easy to use. CONS: Require tons of light to make good food photos, and you can't always be in charge of focus or settings. However, the variety of apps available to postprocess your images after you take them can be liberating.

No matter what camera you use, with a few guidelines and plenty of practice you'll be able to capture appetizing images of food for your blog.

WHAT'S THE DIFFERENCE BETWEEN JPEG AND RAW?

Your camera saves your data (the image) as JPEG or RAW files onto your memory card. A JPEG image is a compressed file that can be saved in a variety of sizes. When shooting in JPEG mode, the camera takes all the data within the frame, applies some settings (like color and contrast, for example), dumps any extra information, and saves it. Sounds easy. And it is, as it results in a much smaller file size that allows you to store a much greater number of images on your memory card. A RAW file is the opposite: it's exactly what comes from your camera sensor, for better or worse. The advantage of a RAW file is that it's almost like a digital negative, allowing you to go back and process to your liking. Your choices are much more limited when shooting JPEG as the camera's done it for you already. Not a big deal if you don't plan to edit your images afterward. But if you need to get back in there and fix some stuff, like color balance or sharpening, it's much easier to do on a RAW file. For the record, I always shoot RAW. Always!

Lenses

A lens isn't just that piece of glass or a small hole that lets the light into the camera. It's an important tool for capturing the subject and will allow you to get close, to get far away, to get wide, and to shoot from just about every point in between. The world of lenses will open up to you if you have a camera with interchangeable lenses (a dSLR), but that doesn't mean there aren't a few things to understand about the lens on a point-and-shoot. Let's address both issues.

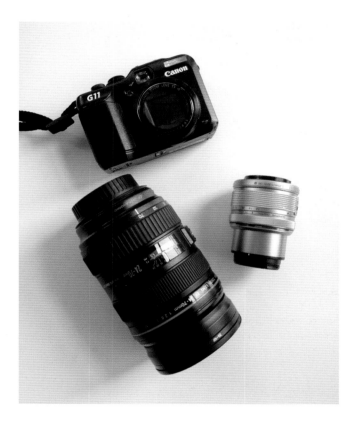

Point-and-Shoot Lenses

When you purchase your compact camera (I'll refer to it as a P&S), you're also purchasing a lens that is built into the camera, something you most likely cannot change (just so you know, there are a few new varieties of P&S cameras that do have interchangeable lenses, but for the sake of this chapter we'll assume that the lens is permanently attached to this type of camera).

Many cameras use optical zooming to allow you to get closer to your subject. This is when the motorized lens extends from the camera. Digital zoom allows the camera to digitally zoom in and crop, bringing you closer to the subject. Digital zooming means your lens won't necessarily telescope and move. With point-and-shoot compact digital cameras, you'll find focusing ranges from 24 mm up to 450 mm and just about everything in between. All these ranges can come in handy when it comes to shooting food. Keep in mind that you may not be able to get super close to your food with a standard lens. Some cameras have a macro feature and allow you to focus very closely.

dSLR Lenses

The world of lenses expands significantly when we talk about dSLR cameras. In a nutshell, you can remove a lens from your dSLR camera and use a different one—they're interchangeable. This is great for a variety of reasons, such as letting you capture your food exactly the way you want. Lenses from this category are also much more specialized. Do you need to zoom in so close that you can see the hair on a raspberry? The macro is for you. Do you need to make sure you cover the top and bottom of a very cramped restaurant kitchen? Think wide angle here.

No matter if it's a point-and-shoot or a dSLR, if you're looking to photograph both wide and detailed images, a good zoom will always help.

Prime versus Zoom

A prime lens (also known as a fixed-focus lens) doesn't have the ability to zoom in or out. In fact, it only focuses at one length, requiring you to physically move closer or farther away from your subject. These lenses tend to be of higher quality and are constructed of better glass than many other lenses. And zoom lenses, well, zoom in and out, allowing you to remain stationary while moving in and out with the lens to increase (or decrease) the field of view.

Camera Modes

Although this feature changes depending on what camera you own, you'll most likely see a dial on top with various modes. These are the camera modes that specify settings (shutter speed and aperture) based on a particular photo need. On many cameras you'll find some basic modes, like P, AV, Tv, and M, and on others you might find them along with scene modes. Scene modes are simplified versions that take the guesswork out of setting up a shot and apply camera settings that apply to that specific scenario.

UNDERSTANDING MEGAPIXELS

Cameras capture their images on a sensor through millions of dots of light, known as megapixels. In a nutshell, the more pixels on a sensor, the more information in your image. Of course, sensor sizes change as well, depending on cameras, too. So when you see an image taken with an 8-megapixel camera, you're looking at 8 million pixels; with a 16-megapixel image, you're looking at 16 million pixels; and so on.

But is it enough? Since food blogging exists mainly online (and onscreen), most cameras today have sufficient megapixels to view onscreen. If you're printing out your food images for a book or a billboard, well, megapixels begin to matter a bit more.

P: Program Mode. The camera sets the shutter and aperture automatically but still lets you access a few settings.

Tv or S: Shutter Priority. This mode lets you pick your own shutter speed while the camera picks the aperture.

Av: Aperture Priority. This mode lets you pick your aperture and the camera selects the appropriate shutter speed.

M: Manual. This setting allows you to select your own shutter speed and aperture. In this mode you tell your camera what to do.

Full Automatic Mode, Auto: This icon can change depending on camera but in this mode the camera does everything for you. That can be a good and a bad thing.

Scene Modes

Scene modes simplify things by giving you real-world settings.

Landscape Mode: This mode keeps both the foreground and background in focus. It does this by increasing the depth of field with a higher f-stop.

Portrait Mode: This mode uses a shallow depth of field so that your subject is in focus while your background is blurry. This setting can work for food, too.

Macro Mode: This allows the camera to focus on something very close to your lens, but how close you can get depends on your camera. It also blurs the background nicely and is a good setting for food photos.

Sports Mode: This mode utilizes a fast shutter speed to freeze the action of someone throwing a ball or anything else that moves rather quickly. You'll need plenty of light to make this work for you, but it's a great setting for catching a chef tossing something in a pan or for anywhere else you see quick movement.

Keep in mind that for our purposes here you may not even use many of your scene modes because we're primarily photographing food.

When I began taking photos of food, I relied on anything automatic—the dial never changed from the fully auto mode! And you know what? That was okay! In fact, I recommend shooting auto at first until you're comfortable with your camera. Then you can graduate to other modes if you're so inclined. But whatever you do, promise me one thing: you will not berate yourself nor feel bad for only shooting in auto mode. Be easy on yourself.

There are several more camera modes, and it all depends on what kind of camera you use: nighttime mode, creative fun modes, panorama, pinhole, Instagram filters, Hipstamatic, I could go on. But for food photography, I'll stick to the things that pertain to shooting food. Of course, that doesn't mean you can't have fun with the other settings. Explore!

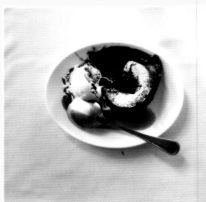

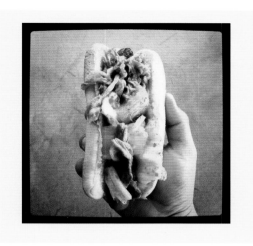

So which lenses do I use to photograph food? I'm glad you asked! I prefer a 100 mm lens because it will allow me to get really close to my food when needed, and, of course, I can always back up to fit more into the frame. When I find that the macro lens is just too tight, I'll go with a 24-70 mm lens, which is what I use for traveling, too. But I'd recommend lenses like a 50 mm, 60 mm, 100 mm and a versatile zoom to let you move around a bit

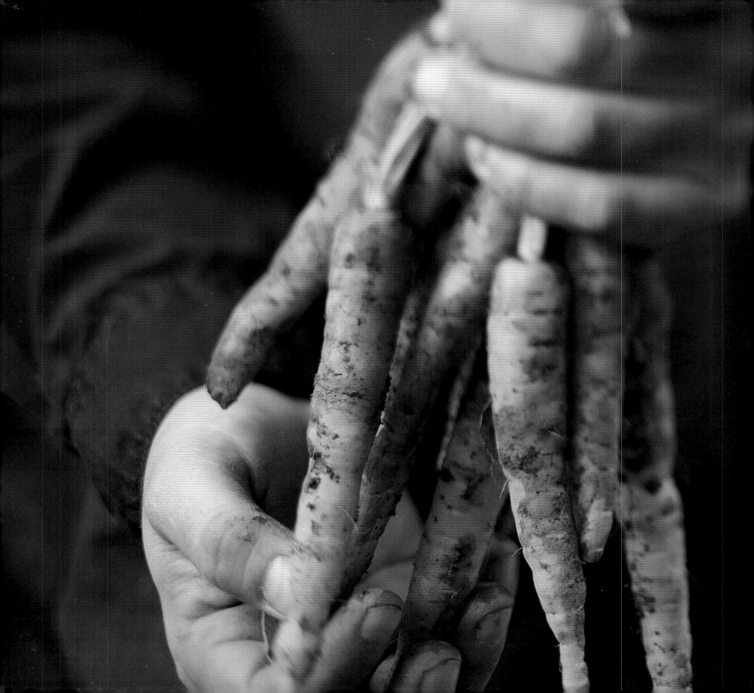

Chapter 3: Depth of Field

Ladies and gentleman, step right up while I show you one of the magical and most mystical qualities of photography! You simply won't believe your eyes. It's quite possibly the most amazing trick you've ever seen coming from a camera!

Okay, I'm being a bit silly. Why? Because as I speak with new photographers at workshops or blogging conferences and we begin to discuss technical stuff, the concept of depth of field comes up as if it's this mythical beast, a magic act that casts a romantic blur across every single food image. In reality, it's just another tool in our toolbox, a product of mechanics and light coming together inside a camera and resulting in what we call selective focus, bokeh, blur, and shallow depth of field.

In a nutshell, the amount of light coming into a lens combined with the length of time a shutter stays open creates an exposure. I'll repeat, the amount of light coming into a lens combined with the length of time a shutter stays open creates an exposure.

Okay, sometimes it's a bit confusing. But it needn't be. Let's just remember two things: shutter and aperture.

Repeat after me: shutter and aperture.

These two nifty things perform two completely different functions, but they work together. They always work together.

The aperture is just like your eye's iris in that it can change shape to allow more or less light in. This is what we call the f-stop.

The shutter is a door that opens and closes and lets light hit the sensor (or film). It only opens and closes, but we can control exactly how quickly or slowly it stays open. This is what we call shutter speed.

In a camera's manual settings, it's all up to you to control both the shutter and the aperture. If this sounds a bit too complicated, remember that many cameras will

handle this for you or let you control half of it through the Aperture Priority mode, sometimes called AV mode.

(See page 53 in "Equipment: Using What Ya Got!" for an explanation of camera modes.)

Understanding F-stop: A Visual Explanation

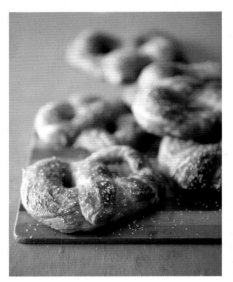 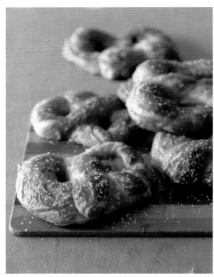 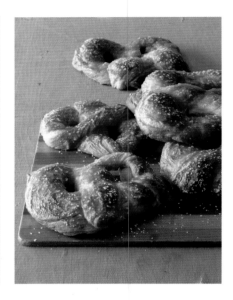

These pretzels were photographed at different settings to show you exactly what happens when we change apertures. The shallow depth of field was photographed at f/2.8, the center image at f/7, and the sharp image at f/32.

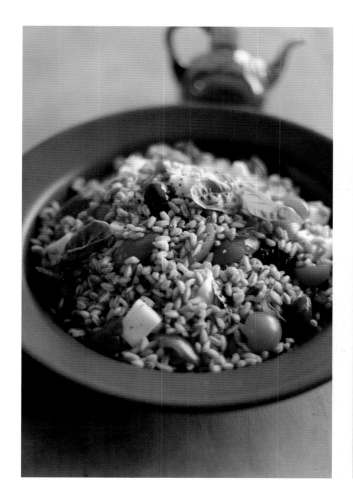
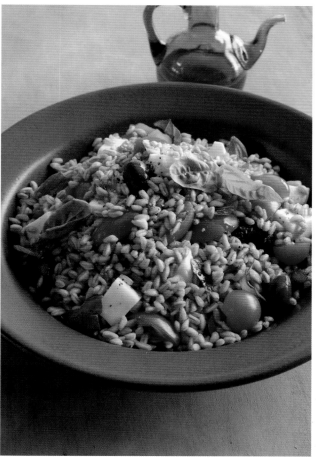

This salad was photographed at f/2.8 and f/11. You'll notice the biggest difference in the bottle of salad dressing and how it falls out of focus.

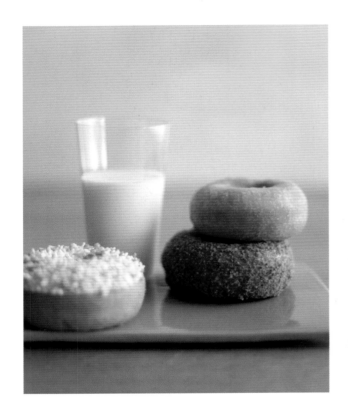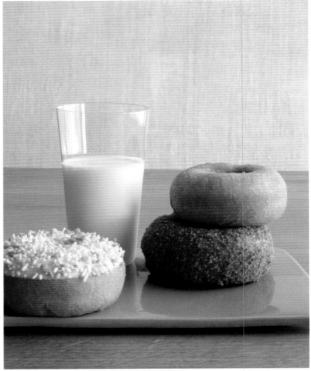

Donuts at f/1.8 for maximum blur and f/22 for maximum sprinkle detail! It's really all a matter of preference.

Like angle and lighting, selective focus is a tool that should be used thoughtfully. It has a tendency to be over-used, resulting in images that often blur a bit too much of the information inside the photo. Think of what you are trying to say: Is it important for the viewer to see everything in the image? Conversely, you can use depth of field to make the eye go straight to the focal point, ignoring the details around the subject. It goes both ways.

This whole discussion about depth of field applies to cameras with lenses that allow you to change it, in a nutshell. But just because you're using a camera phone or point-and-shoot doesn't mean you can't have fun with it, too! Many phone apps allow you to change the focal area via software, and editing programs on your computer are capable of producing similar results as well.

A word of caution: too much tweaking can make things look a wee bit fake. Just saying.

Remember, we can flip this whole idea around and think of shutter speeds as a way of making things sharp, freeze motion, create blur, and so on. Shutter and aperture work together!

I wanted the really long artichoke stems to be blurred so that the eye went straight to the front of the thistle. And yes, with melted butter these were fantastic!

Chapter 4: A Light Introduction

Simply stated, you cannot have photography without light. Even the origin of the word itself includes the Latin word for "light." And next to the food itself, light is the most important aspect to food photography. It illuminates the subject, it shines through objects, it washes over and bathes the plate, or it peaks through and highlights only selected areas. No matter how you use it, it's necessary to do our thing. It lights up our lives.

However, not all light is created equal. It's hot and cold, hard and soft, cool and warm, smooth and harsh, and just about everything in between. It can come from a candle, a flashlight, a strobe, a flash, a desk lamp, the sun—you name it. But no matter your light source, understanding it and harnessing it to suit your needs is the name of the game. Control your light effectively, and you'll get great photos every time.

Different Light Sources, Different Types of Light

Although all light illuminates, it doesn't illuminate equally. Simply look around you, right now, and see how many light sources you may find. If you're reading this book sprawled out on a picnic blanket at the park (yay, you!), then chances are you're only going to see the sun. But if you're at your desk or at home, you might have your computer monitor lighting up your home office, an overhead light filling the room, a small desk lamp next to the couch, a small window or patio door, even a candle in the kitchen. Although all these items do the same thing, they go about doing them with their own characteristics. Understanding each source and how to make it work for you is crucial in food photography.

Light can be broken down into two sources: natural and artificial. Natural light is daylight; artificial light includes strobes, flashes, light boxes, lamps, and anything else manufactured to produce light. Luckily for the field of food photography, natural light is ample, sufficient, and in many cases optimum. And it's free. You can't beat that! But even if you don't have access to natural light (think windowless room, photographing at night), you needn't worry—you'll be able to get great results no matter the light source.

Also, we can't forget the flash that is attached to our cameras. I'll refer to this as on-camera flash, and we'll dedicate some time to it specifically. A word of warning: It can be tricky with food.

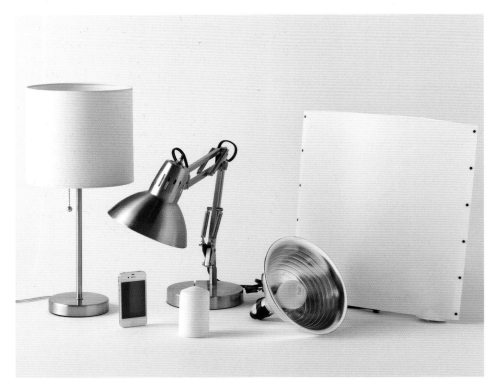

Light can come from many sources. If you learn their properties and how to harness them, you can use them to your advantage.

Measuring Light: Intensity and Temperature

The cool blue of dusk. The bright yellow of a sunny early morning. The pale green of fluorescent office lights. All visible light has a color temperature that is measured with a term called *Kelvin*. This is important because one must understand the temperature of light in order to work with it most effectively. And color temperature matters greatly when it comes time to implement the best color balance process for your photos. More on that later in this book on page 61.

When it comes to measuring the intensity of light, we use something called *lumens*. Luckily for us, a plate of food on a table doesn't move all that much.

When photographing food, it's important to remember that if you use a tripod and a longer exposure, tons and tons of light isn't necessary. Food generally stays still (unless you're talking an action shot like pouring chocolate or a splash), so you won't need a room full of expensive lights to shoot it. Sometimes just one small desk lamp can do the trick, and if you have a few light modifiers you'll find that you have everything you need.

Modify That Light!

No matter the light source, chances are you'll have to modify it to get it to perform the way you want it to. But what does "modify light" mean? Simple. It's taking the main light, whether it's hard light or soft light, and altering it with materials or objects to shape it, diffuse it, supplement it, or subtract it. We'll look at different ways to achieve this.

Light from a window or desk lamp is good, but it may not have the quality you need for a photo of food. Taking the direction of a soft box (which is a device that modifies light to spread it and make it softer), you can take a variety of materials such as fabric or paper and place it between the light and your subject. This gives you a softer, more even light. Remember, this is a preference for some and not a hard or fast rule! Experiment with your light to achieve the results you think look best. And in those moments when I have to use a desk lamp or utility lamp, I'll make sure to shine it into a piece of foam core to diffuse it.

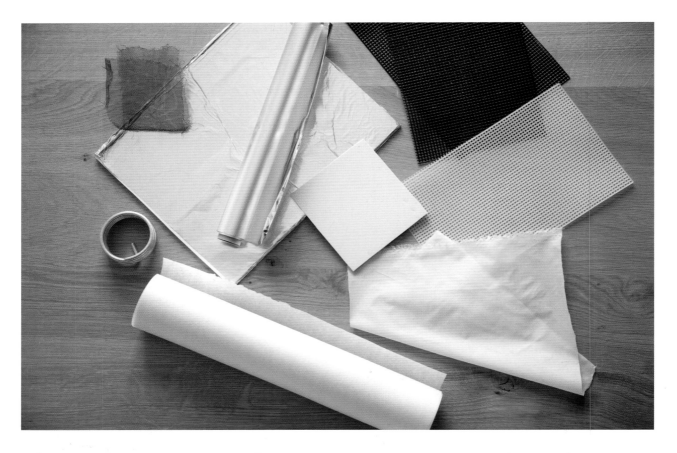

Wax paper, inexpensive foam core, screen material, needlepoint screen, aluminum foil—all these things can be used to add light, bounce light, subtract light, modify light, I could go on and on. And none of these cost too much money, either!

Okay we've talked about how to soften and diffuse the light, but how can we increase it or get it to go where we need it to? That's where reflectors, bounces, and fill cards come in handy. A fill card is exactly what it sounds like: it reflects like light with the ability to go wherever needed (we also call this a bounce card). A bounce or fill card can be a piece of foam core, a napkin, a bed sheet, Styrofoam, cardboard, you name it—anything that reflects light is usable.

Whereas white surfaces give you even light, a reflector is usually metallic (or gold) in color and reflects light, but in a much different way than white. Reflectors give harder reflections that can be appropriate at times but should be used judiciously. A little goes a long way.

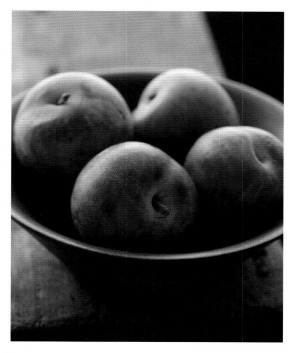 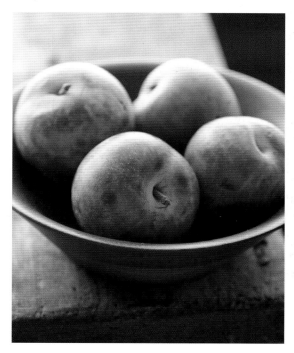

A small piece of white foam core was placed next to this bowl of pluots, directly outside the camera's view. It helped make this darker image (left) a whole lot brighter (right). No lights required.

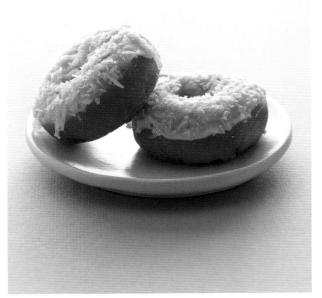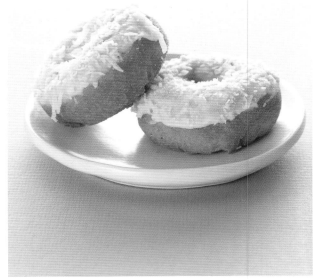

Here's an extreme example of what filling the subject can do. I used a poster-sized white matte board to reflect light back onto the subject, but in reality I'd probably back up, move the matte board back, and aim for something between these two images.

There may be times where you don't need to reflect or fill. In fact, you may find yourself with too much light! Remember, we don't always need a lot for food photography. When this happens, you can easily apply the same principles of filling and reflecting in the opposite way: removing and blocking light. You can actually use many of the same materials but may also want to get your hands on darker items like construction paper, black foam core, and so on.

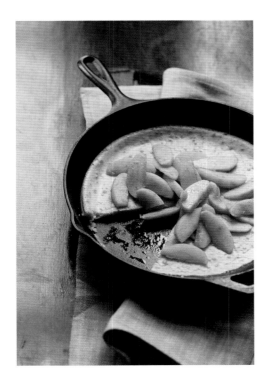

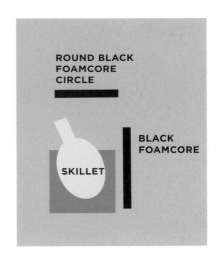

WINDOW

ROUND BLACK FOAMCORE CIRCLE

SKILLET

BLACK FOAMCORE

CAMERA

I wanted to show more edges in this magazine photo, and I wanted to emphasize the black of the skillet because it's crucial to the recipe. I did this by placing black pieces of square and round foam core around my subject.

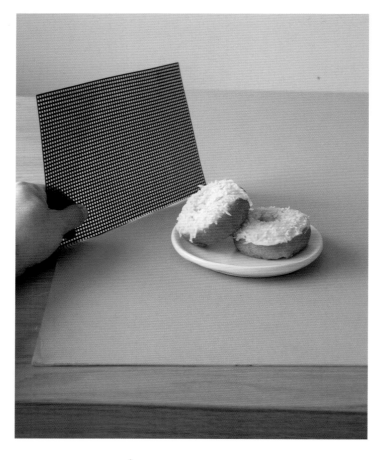

For moments when I don't necessarily want to block light completely but I do want to bring it down just a bit, I'll use a screen or a piece of nylon needlepoint screen. This especially helps when I need detail in foods like white mashed potatoes, cake frosting, or ice cream.

SCRIMMING/DIFFUSING	Use paper, nylon fabric, vellum, wax paper, curtain
TO EVEN OUT AND SOFTEN LIGHT	
REFLECTING/BOUNCING	Use foil, white paper, mirrors, foamcore, reflectors
TO FILL AND INCREASE LIGHT	
BLOCKING/REMOVING	Use cardboard, black foamcore, fabric, plastic needlepoint canvas, mesh screens
TO DECREASE LIGHT AND CONTROL HIGHLIGHTS	

You can use professional photography supplies or household items—you don't need to break the bank!

Scrims, Diffusions, Hard and Soft Light

You'll often see scrims, soft boxes, and diffusion panels at photography studios. These are simply tools used to diffuse and soften light and change it from hard light to soft light. In a nutshell, hard light is usually one source that hits the subject directly, causing a shadow. Think of a single bare lightbulb in a room. Soft light is the opposite; although it can still be a single source, it hits the subject differently and usually indirectly, resulting in less contrast and softer shadows. You'll generally see softer light used in food photography, but remember there are always exceptions.

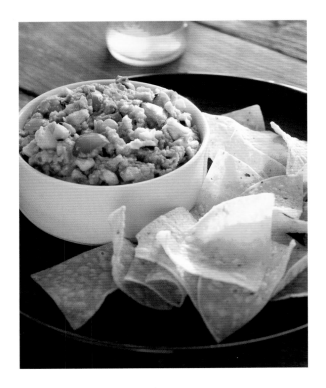 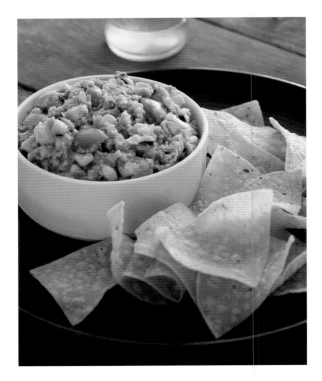

Sunlight from the window was shining in on this plate of chips and guacamole. To change hard light to soft light, all I did was place a scrim between the window and the table, resulting in a softer look. Scrimming and blocking light will often change the exposure, so you'll need to compensate.

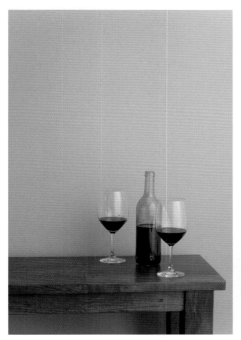 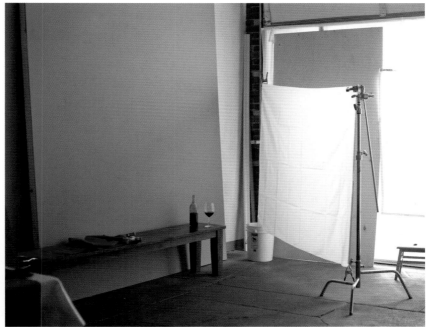

Using large pieces of fabric as scrims can also take care of highlights in reflective surfaces. Here I used a large piece of nylon fabric to diffuse the light one additional time. You can do it multiple times if needed!

I used a large diffusion panel called a Scrim Jim from Westcott to even some of the lighting out on the pretzels.

I often tell people that when it comes to food photography, think of light as water. It's what bathes and washes over the subject. Or it's also what drips and sprinkles over the subject, depending on the amount. Faucets, spigots, hoses, containers, cups, and other things used to control water have a parallel in lighting a scene for food photography.

Location, Location, Location!

If you learn one thing from this chapter, I hope it's this: *Food loves directional light.* It's true. It adores it and makes it look its best. What do I mean by directional light? It's light from one main source next to your food (see the "Difficult Foods to Photograph and What You Can Do about It" chapter on page 175 for some lighting diagrams). Of course, there are always exceptions to every rule, but keep this one in the forefront of your mind as you compose your photos. Trust me on this one.

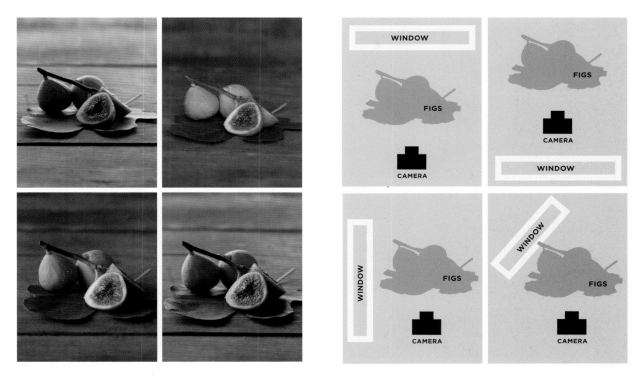

These figs were photographed in different positions to illustrate how the direction of a light source can change the subject drastically. It's also worth noting that the surface changes as well.

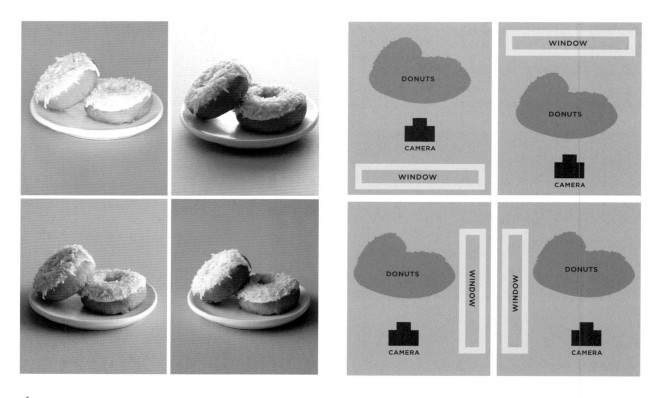

Again, changing the light direction changes the look of each frame.

I really hate to speak in absolutes, but whereas the flash on your camera might work well for family portraits, it does nothing for food shots. I'll go so far as to say I never use it. Ever. Better to turn it off, grab a tripod, and find another (and better) light source.

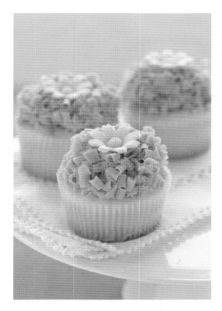

A giant window makes these cupcakes happy in the image on the left. Closing the blinds and using a desk lamp would work as a plan B (center image). However, the image on the right uses the on-camera flash and, well, our cupcakes are no longer happy.

Using Different Sources of Light

I've visited places that had no sunlight whatsoever during winter (my friends in Alaska, I'm looking at you). That doesn't mean you can't snap photos of your food; it only means you'll need to use other light sources to get the job done.

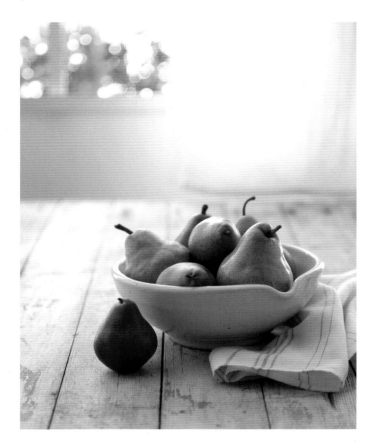

I'm using a bowl of pears as an example, and here they are sitting on a table that's illuminated by a big window.

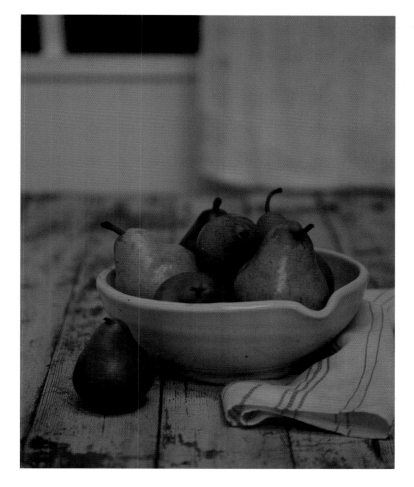

Later in the day, without daylight but with the overhead light turned on. Now you can see why this simply won't work. Even if this image were properly color balanced, it still wouldn't have the visual impact of using a directional light.

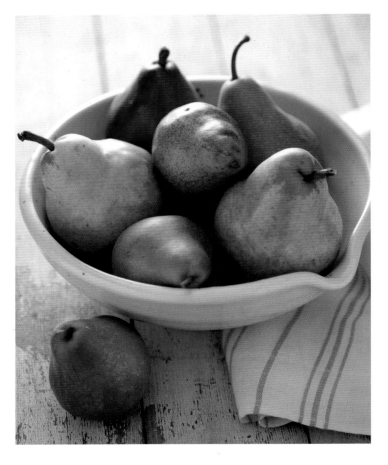

Time to bring out the Lowel Ego, my small tabletop lamp that
provides a nice, soft light for product and food photography.
In this case I decided to use it behind my bowl of pears with
fill cards to the front left and right as well as one above for
additional light.

I pulled back a bit so that you can see how this image was photographed. Although this was in my studio, this setup could easily be arranged on the floor, kitchen counter, or desk in your home.

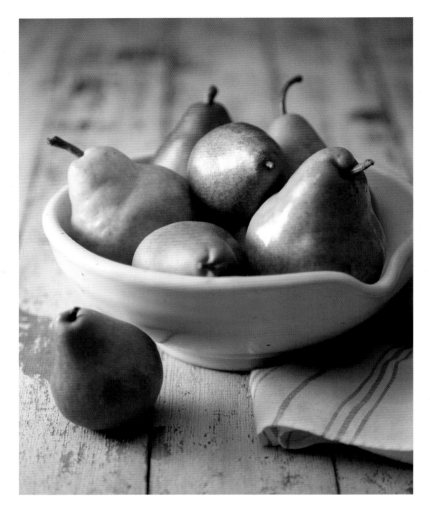

Again with my Lowel Ego light, I switched to a side-lighting scenario for this version. I like how the pears look, but the back seems a bit dark.

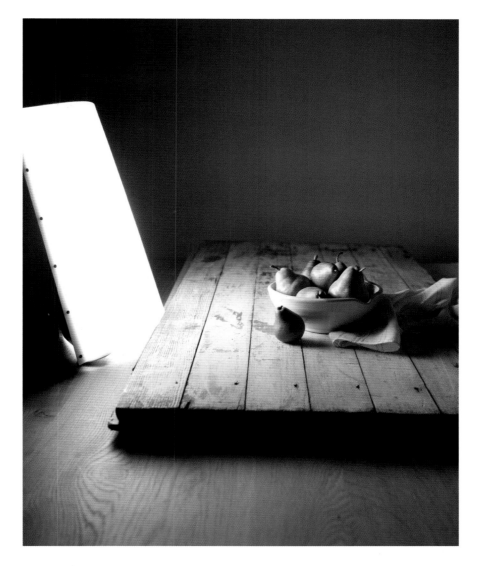

Here's the setup for the previous image.

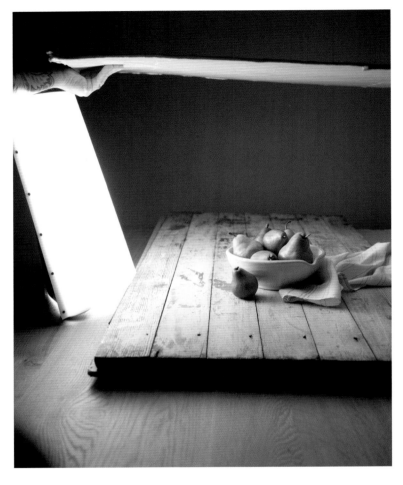

By placing a piece of foam core above, I am able to reflect light onto the area behind the pears so that it's not so dark. Bounce cards come in handy when you don't want to use an additional light source or lamp.

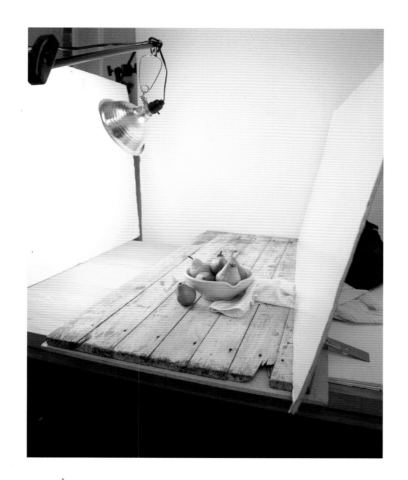

Suppose you don't want to invest in a tabletop product photography light. You don't have to! Here I used an $8 utility lamp with a bright light bulb and shined it into white foam core. I also used another piece taped to an L bracket for stability as fill. The result?

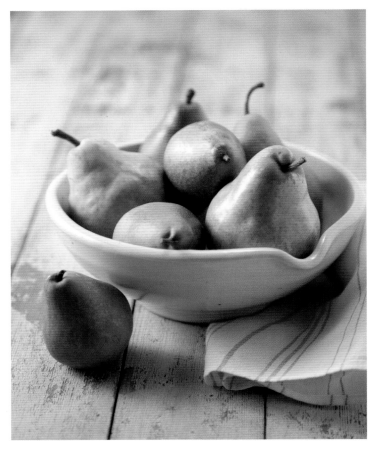

I'm pretty darn happy with the light in this photo, and it goes to show you that you don't need expensive gear to get great results. Of course, I had to pay attention to my white balance and correct it, but that was about the most technical thing I needed to do.

Chapter 5: Equipment: Using What Ya Got!

In a perfect world we'd be able to head to that camera shop, hop on a website, and fill our basket with the latest and greatest camera gear. Then six months later, we could do it again when the next big piece of impressive camera gear came to market. I don't know about you, but unfortunately I can't do that. Besides, I like to get to know my equipment, for better or worse.

I'm not always in my studio creating food images. Sometimes I'm snapping shots for my blog while traveling with a point-and-shoot; other times I'm at a restaurant using my iPhone. No matter what gear I have in my hand, the principles and best practices remain the same. In this chapter, I'm going to take a look at creating food imagery with a variety of cameras, using things that you probably have around the house. We'll put these things into practice to see how it's simple to use what you've got instead of breaking the bank.

MAYBE YA ALREADY GOT IT (MAYBE YOU DON'T)

Although I'm a big proponent of using things you already have on hand, one item I encourage all budding photographers to purchase is a tripod. It doesn't have to be expensive, either. A tripod allows you to frame your shot, shoot longer exposures, and keep your subject still and in place while you frame your shot. You don't always have to use it, but it's certainly a great piece of equipment to have.

When shopping for a tripod, make sure to check for stability and height at a price point you can afford. Keep in mind that a hefty dSLR camera with a big lens will need considerable strength to keep it from falling over. Just the thought makes me break out into a sweat.

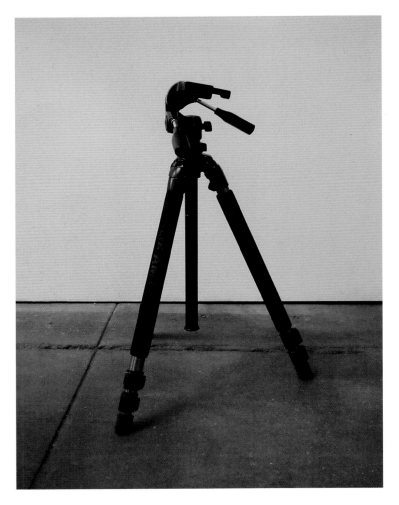

I have a few tripods, which vary in height and weight, that I'll use depending on the assignment. But you don't need to spend a fortune. You can find good deals at your local camera shop, electronic retailer, or Amazon.

Creamy White Bean Dip

Let's start with something a bit healthy but still savory and fun. This is a creamy white bean dip that I photographed for Food Network. I thought it'd be a perfect, simple example of how different cameras capture the same image, but also that sometimes it's not really about what you don't have but what you do have at your disposal.

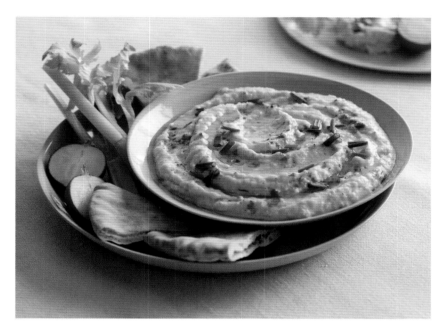

So what do things look like when I grab a variety of cameras, put them on a tripod, and utilize the same lighting and set?

This first image was photographed with a Canon 5D Mark II and a 100mm macro lens. I used natural light coming from around the 1 o'clock position without any fill cards or reflectors. Remember, I wanted to keep this simple and it just goes to show you: sometimes simple is best, especially when it comes to letting the food take center stage.

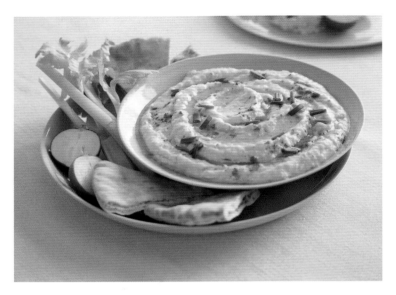

This was photographed using an Olympus Pen Mini with a 14-42mm lens. All things being equal, well, I'm really pleased with how well this image came out from a little camera.

I used a Canon GII for this with its built-in zoom lens. Not bad! It might require some contrast and color boosting in Photoshop, but many images do.

I went way back into my camera storage box and pulled out this Canon Powershot SD 550 from a few years ago. Yes, the file needs a little bit of TLC in the color and contrast department, but you know what? It's remarkably good! I'd have no problem using this file on my blog at all, although the resolution might not be there to use in the print world.

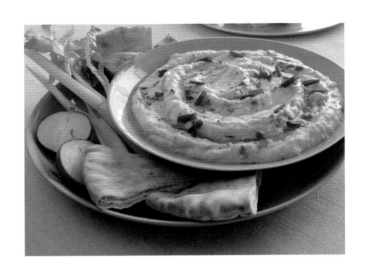

Although the plates were specially ordered from Australia, the blue fabric used underneath cost $3 a yard and I only needed a small portion of it. Think simple! And when it comes to light modifiers, remember that cardboard, foam core, paper, even bed sheets can work!

Who says you can't use a cell phone to shoot food? I certainly don't make that claim! This is an iPhone 4S image, and I happen to think the cell phone did pretty well. Of course, you're stuck using the built-in lens and have to use digital zoom (or move your camera around), but it would work in a pinch.

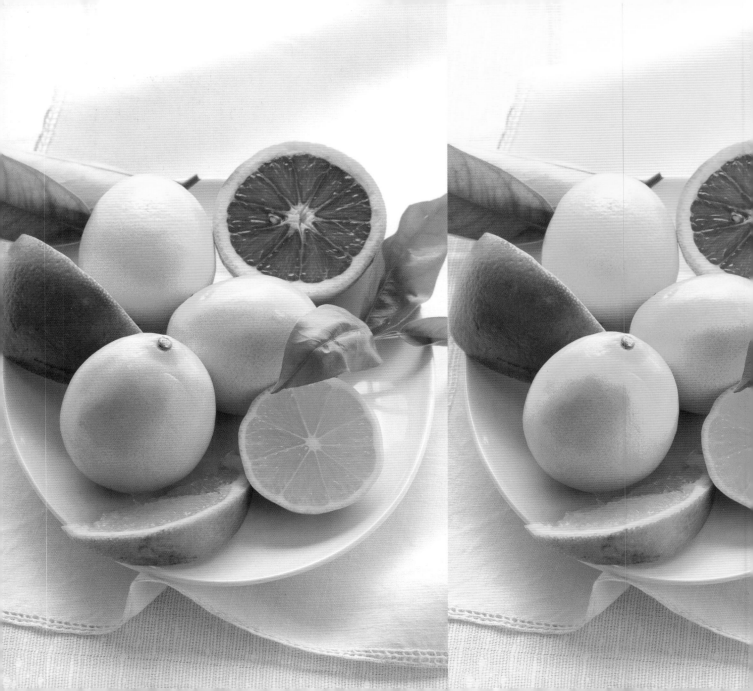

Chapter 6: Color Temperature and White Balance

The proper white balance can make all the difference in the world!

On page 29 I briefly touched on color temperature and white balance. All you have to do is think of a sunset to understand color temperature. Golden hues of yellow light shine everywhere, and that specific light is measured in a linear scale called Kelvin.

Different types of light sources give off color that we can measure and assign a value. In the simplest of terms, light sources can run from warm to cool, with neutral light falling right in the middle. This is easy to understand when you look at light temperatures on a chart (see image on p. 62). An improperly white-balanced image is a surefire way to make a food image scream "beginner"! Although there's nothing wrong with being a beginner (we all gotta start somewhere!), paying attention to colors

and your white balance can take your image from not so hot to pretty darn beautiful in a few short steps.

Understanding White Balance

There are two basic ways to approach white balancing in photography as it relates to us food bloggers: in camera and in post. "In camera" simply means taking care of business with your camera, applying all settings here before you snap your photo. "In post" means you can color correct or balance after you've taken your photo, via Photoshop, Lightroom, or whatever program you use in your workflow. Because it's not always easy to fix an image after the fact, taking the time to properly adjust your camera settings will save you some work and maybe even a few headaches later.

Understanding Camera Settings

Many cameras have settings that will take care of the white balance for you. Navigate yourself to the proper menu, pick your setting, and voila! It's done! Even though we discussed Kelvin and there's a nifty chart of color temperatures, I advise you to use your eyes to see what looks best. This way you don't really need to find out the exact temperature of your light source; if you start with a basic understanding, you're already so close.

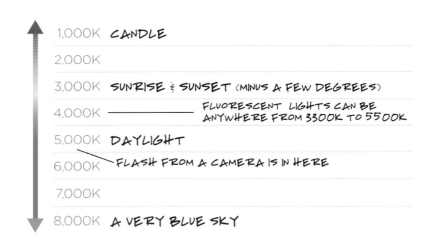

1,000K	CANDLE
2,000K	
3,000K	SUNRISE & SUNSET (MINUS A FEW DEGREES)
4,000K	——————— FLUORESCENT LIGHTS CAN BE ANYWHERE FROM 3300K TO 5500K
5,000K	DAYLIGHT
6,000K	FLASH FROM A CAMERA IS IN HERE
7,000K	
8,000K	A VERY BLUE SKY

Setting White Balance on the Camera

Depending on what camera I use, I generally keep my white balance (known as "WB") set to Auto. This way I let the camera do everything for me, and I find it's generally correct. Keep in mind that with food photography I'm not really mixing light sources with different temperatures; I'm using window light (it's one color) or a strobe (it's one color), and find I don't have to fight it or fix the white balance all that much. Walk into a restaurant, however, and you might be faced with multiple light sources and find yourself making a quick judgment call on white balance.

Some cameras will allow you to set your custom white balance by photographing a white piece of paper and then setting your white balance based on that shot. This is also a great way to make sure you're getting a proper white balance reading.

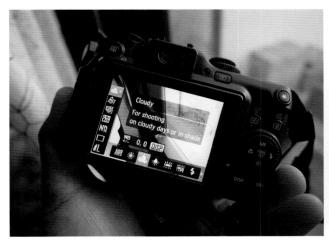 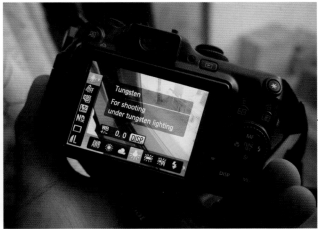

Cameras are different, so there's no one place to tell you where to locate your white balance settings, but they're most likely in your menu or settings. Once you locate them, scroll through the settings to see how the color changes. It can make a big difference!

Setting White Balance on the Computer

Fortunately for us computer types, programs like Photoshop, Lightroom, and Aperture allow us to easily fix our white balance in two ways: by clicking on a neutral part of the image with an eye-dropper tool or through pull-down menus that run us through various light settings: Auto, Daylight, Cloudy, Shade, Tungsten, Fluorescent, Flash, and Custom. Keep in mind that these features tend to work on RAW images and not JPEG files. But that doesn't mean you can't adjust it for the JPEG images.

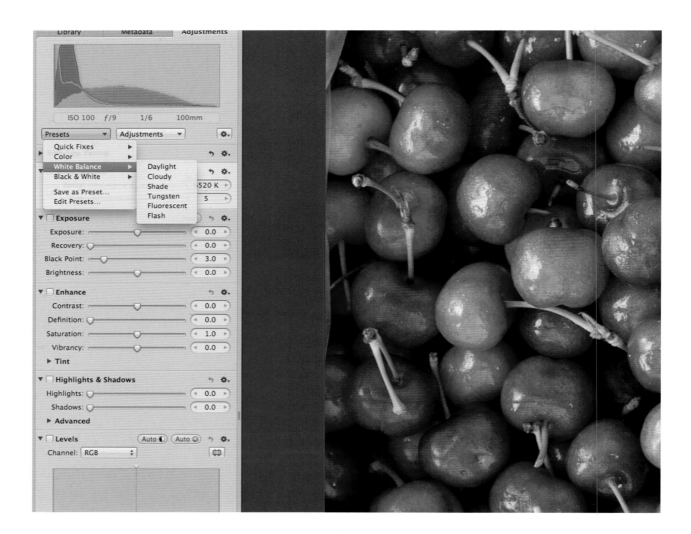

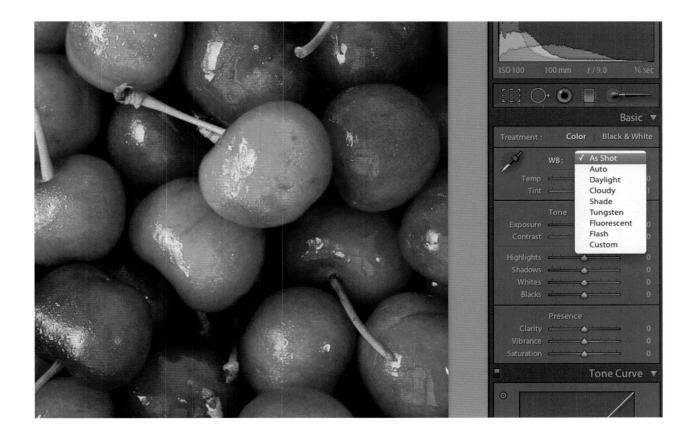

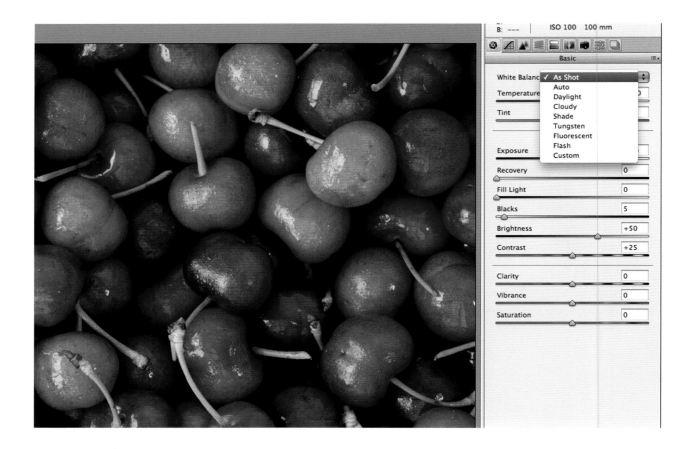

Photo Fixes

Basic edits have a new spot! Look around; some have changed. Then get creative with Effects, Text, and more!

⭐ Auto-Fix

⊟. Crop

↻ Rotate

▣ Exposure

🎨 Colors ?

⭐ Auto-Colors

◼ Neutral Picker

Saturation: 0

Temperature: -4

Apply Cancel

△ Sharpen

🔳 Resize

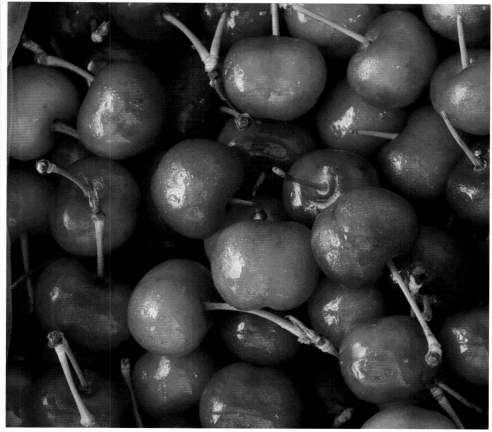

Photo editing software, both premium and free programs, will allow you to set white balance to your already-photographed images. This helps in case you've neglected to set it previously or just don't like the way things look.

But just so we can understand what each white balance setting does, let's look at some settings and how they apply to an image photographed with natural daylight—nothing fancy, just a big window right behind the subject.

Here are our lovely donuts. And yes, I ate them afterward. But I'm keeping the table generally prop-free with minimal clutter so that you can see exactly what happens here.

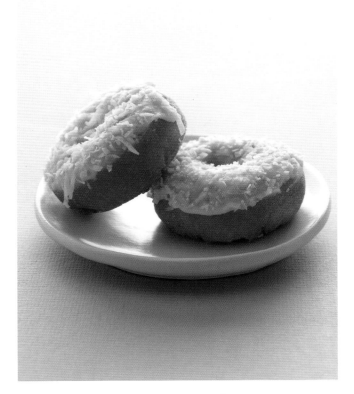

Donuts photographed with a white balance set to Cloudy. Because it was an overcast day, I think this really represents a great accurate color

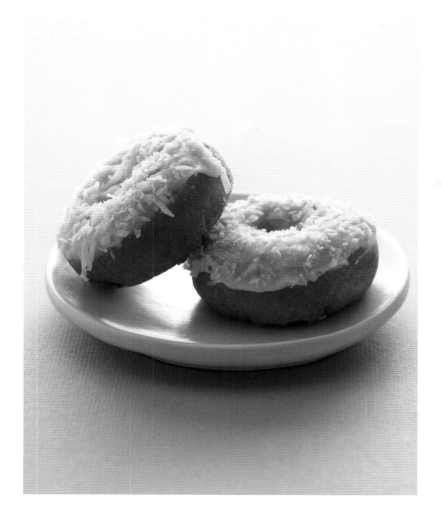

Donuts photographed with a white balance set to Custom. Custom allows me to actually dial in my number on my camera and I took a guess. I think it's okay; it's a little bluish, though.

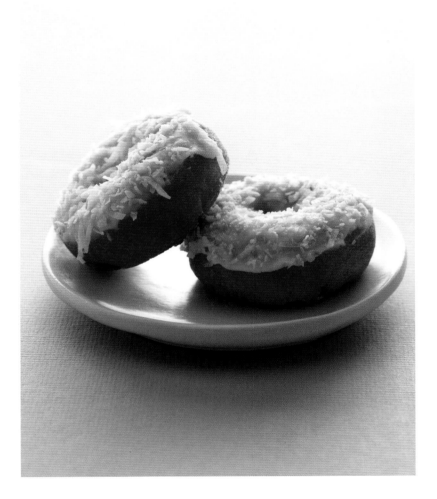

Donuts photographed with a white balance set to Daylight. Hey, look at that. Now you're talking! I'm happy with this setting because, well, I was shooting with daylight!

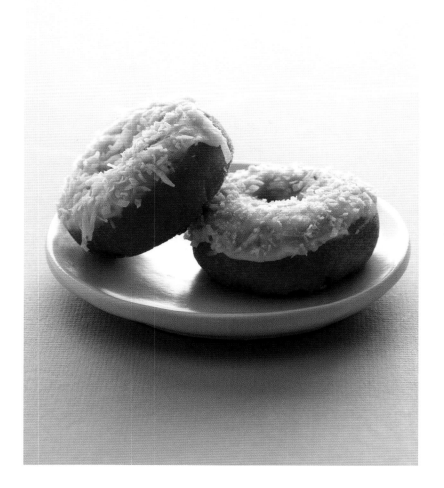

Donuts photographed with a white balance set to Flash. Flashes and strobes have specific color temperatures, and although I wasn't using a flash for this, I think the color is acceptable.

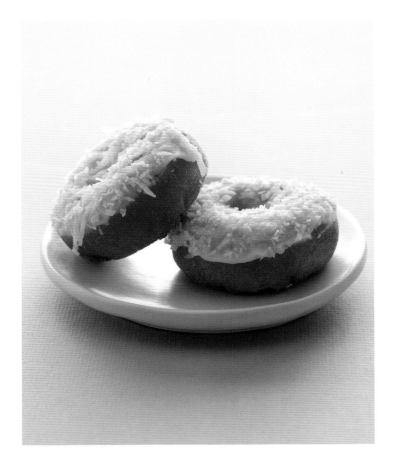

Donuts photographed with a white balance set to Fluorescent. Um, maybe if I were wearing some rose-colored glasses this might be okay. But clearly I'm not, and you're probably not either. This is the wrong color balance unless I'm using overhead fluorescent lights!

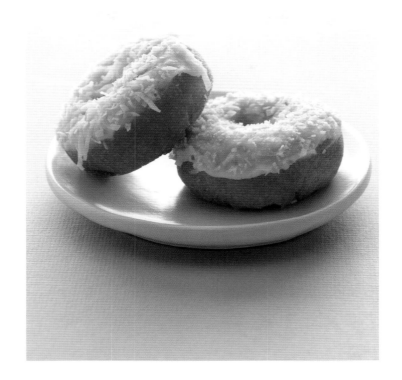

Donuts photographed with a white balance set to Shade. Light that falls in shade usually isn't direct light at all but a reflection of so many factors: the area inside the shade, the light reflected from outside the shade, and so on. It can be specific, but in camera terms it's very close to daylight. Not too bad.

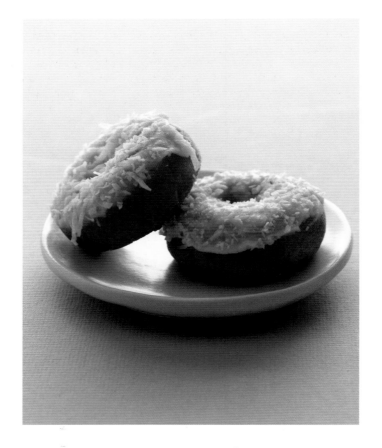

Donuts photographed with a white balance set to Tungsten. Would you like to join me and eat some donuts in the frozen tundra? Because that's really all I can think of when I see this awesomely incorrect white-balanced image. I get chills just looking at it. Of course, everything would be peachy if I were using tungsten lighting as my source. But I wasn't.

This is by no means necessary for great food photography, but for me I don't work without a small gray card or something like an X-rite ColorChecker Passport. No matter what happens with my camera or my light source, as long as I get a photo of my food with a shot of the neutral gray in it I'm able to have 100% accurate color later. How do I use it? After I have my final food photo, I take one additional image with the color checker in the shot, positioning it so that it receives the same amount of light as my food. In my photo editor (in this case Photoshop), I use the eyedropper tool, click on the gray, and voila! Proper color. When working with clients where color is crucial, well, you can see why I rely on this so much!

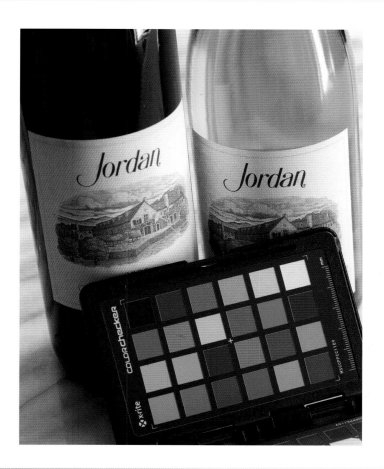

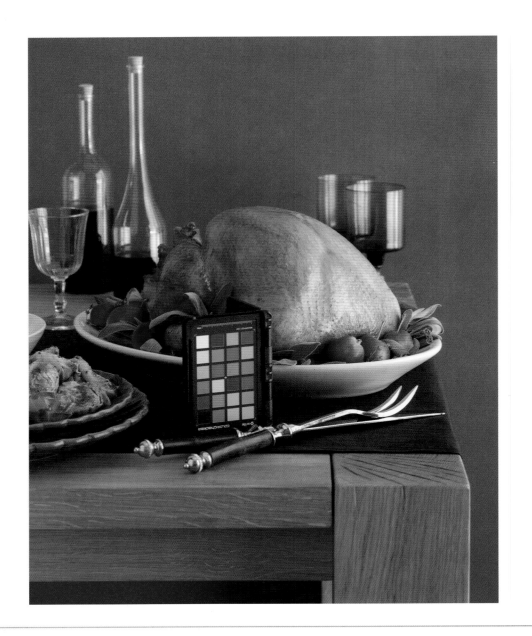

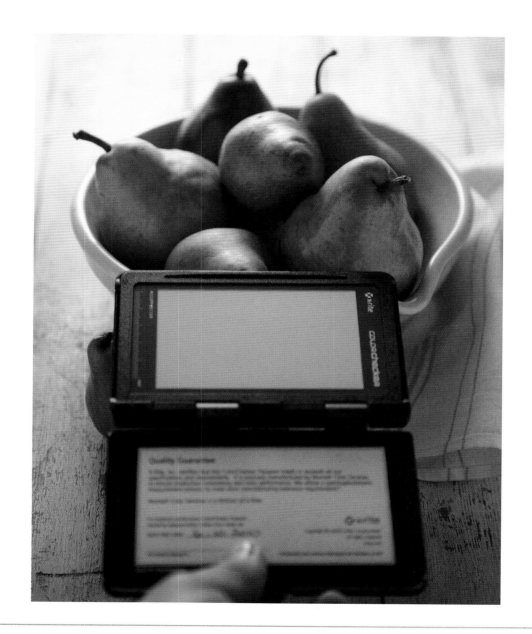

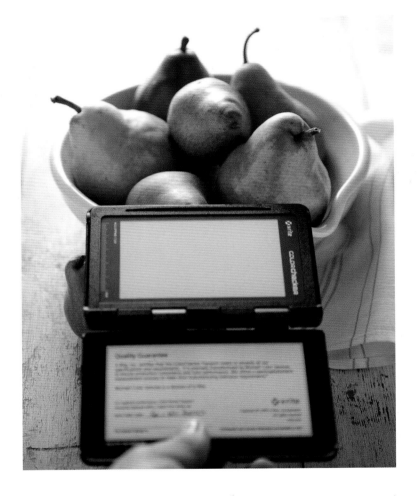

The correct color on these wine bottles is crucial, as is the color on the turkey. And because these pears were photographed with a household lightbulb, I was able to balance it correctly in Photoshop, giving it the accurate color you see above.

I may seem like a stickler over The Importance of a Properly Color Balanced Image, but for good reason. We use so many of our senses before taking that first bite: Does it smell off? Has it sat out too long and gone bad? Improper color balancing can spoil an image, and I mean that in every sense of the word. A bright fresh green salad can appear sallow and old when balanced improperly, for example. That's certainly no fun. And because we can use virtually any light source in food photography, it pays to understand the properties of each one.

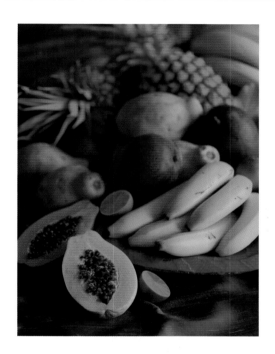 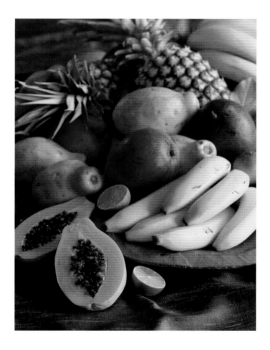

Unless you're skilled in growing Tropical Smurf Fruit, this image is just all sorts of wacky. That's because the white balance wasn't correct. On the right, we've fixed it by shooting it correctly, and what do you know? Luscious, delicious tropical fruit the way it should look. Someone grab me a Piña Colada now.

When Not to Trust Color Balance, Exactly

There's no one-size-fits-all approach when it comes to food photography. Some types of food images (breakfast, pastries, eggs, etc.) are actually okay on the warm side, whereas foods best kept cold (fish, chunks of ice) are okay on the cooler side. Experiment with color balance to find out what you like

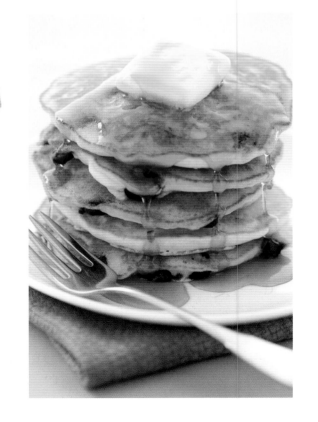

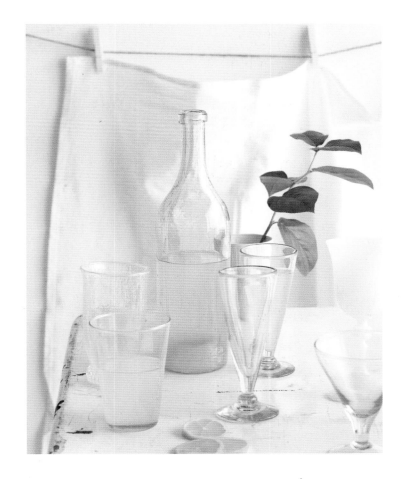

The pancakes on the previous page are a bit warmer than the correct setting should read, but that's okay. I happen to think of golden syrup, warm butter, and fluffy pancakes in the bright morning sun! And the pink lemonade above was photographed a bit cooler to imply a chilly freshness.

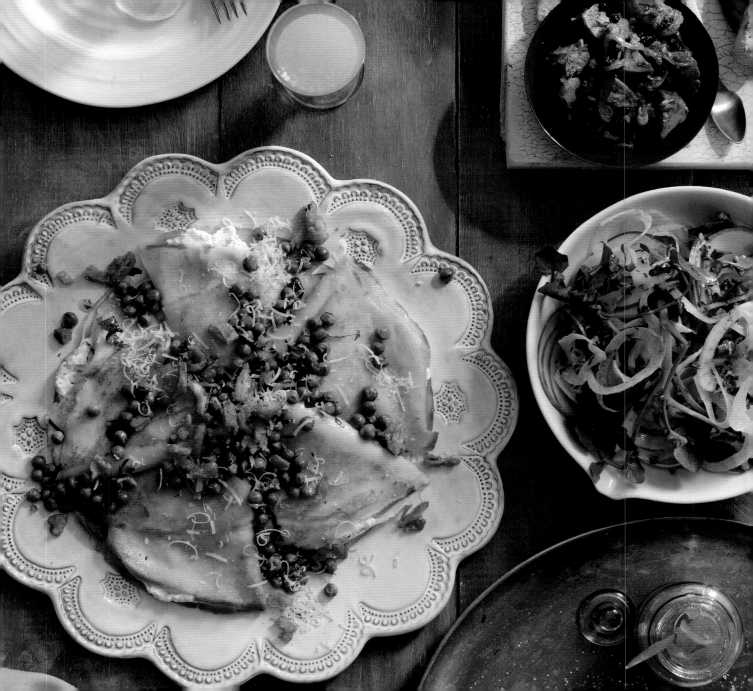

Chapter 7: Workflow

Put 10 food bloggers in a room and inevitably the questions will begin quickly:

"What are you processing your images with?"

"How are you archiving and backing up?"

"Are you shooting RAW or JPEG?"

"Are you applying any filters or sharpening your images? Do you retouch much?"

All of these questions fall under the umbrella of a workflow, the process that begins with snapping a photo and continues all the way through to its final use. And just like snowflakes, no workflow is exactly the same. What may work for one blogger might not work for another depending on how the bloggers use their images and what software they choose to use, and that's cool. But by sharing workflows and ideas, we may all find something that helps us become more efficient, more confident, and more comfortable in this process of food photography. And that's good!

What is my personal workflow? In a perfect world I'd have a one-size-fits-all approach to my workflow, but it ain't always so. Because I shoot with many different cameras, sometimes the software required to edit the files is proprietary to that specific camera's native file. My workflow consists of always shooting RAW, sometimes tethered to my computer, sometimes not, followed by an initial review in different software. I use Capture One, Digital Photo Professional from Canon, Adobe Lightroom, and Olympus Viewer. Of course, those are the programs I'm currently using, which will probably change by the time you read this!

Keep in mind that my workflow is basically the same whether I'm in a studio or at home, just slightly modified. The key to efficiency is organization!

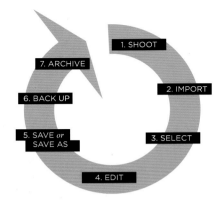

1. SHOOT
2. IMPORT
3. SELECT
4. EDIT
5. SAVE *or* SAVE AS
6. BACK UP
7. ARCHIVE

1. *Shoot.* This is pretty basic and exactly what it sounds like. And I could be shooting in my studio or shooting a bowl of pasta at home for my blog. This step doesn't always have to happen in one setting, either.

2. *Import.* There are several ways to get the images from a camera into a computer. You can use card readers or connect your camera directly to your computer via a USB cable. It all depends on the type of transfer your camera and computer will allow. There are wireless transfers, too! And importing to your computer isn't the only step here, as you'll want to get your images into a program that allows you to view them. Programs like Lightroom, Aperture, and iPhoto handle all of these tasks and allow you to move on to the next step.

3. *Select.* This is the process of making your selections from the dozens of images you may happen to have photographed. For me I'll get rid of the duds (there are always tons of them, trust me) and the ones that aren't quite worth saving. Depending on which program I use, this can be as easy as selecting a number or starring them so that they have a rating.

4. *Edit.* Here's where you'll fix your images for color, contrast, sharpening, rotation, blemish removal, and anything else you may need to do to make them ready for prime time.

5. *Save.* We're probably all using different cameras with various megapixels, so I'll keep this as general as possible because it relates to blogging and online use: I'll save one image as a high-resolution file and another at 72 dots per inch (dpi) for web use. All files for the Internet should be saved at a web-ready resolution, 72 dpi at their final size. This depends on your blog's column or gallery space. Anything larger and you're just creating longer load times.

6. *Copy.* Once I'm done with my images, I copy them to an external drive (sometimes several) and burn to a disk if needed. I also use an online storage service so that I have access to them no matter where I am.

7. *Store.* Once everything is backed up and I have duplicate copies, I'll store them at the studio, at home, or offsite.

WORKING WITH COPIES

I didn't mention this previously, but it's a good idea to work from copies or to actually create copies before you begin the editing process, just in case. And I won't erase or reformat my camera's memory card until I know I've successfully copied over *and* backed up all of my image files. It pays to back up!

Sometimes I shoot *tethered*, which means my camera is connected to my computer and downloads the images as I take them. It really comes in handy to see the images as they are taken. Other times I'll shoot to my memory card in the camera and then download via a card reader (most often when shooting at a restaurant or on location).

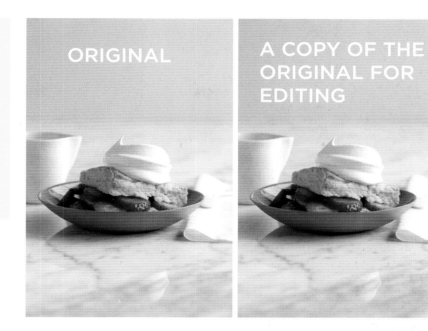

ORIGINAL

A COPY OF THE ORIGINAL FOR EDITING

I always work on a copy when I am color correcting or retouching the dust or blemishes on a surface, like I did on this cover image.

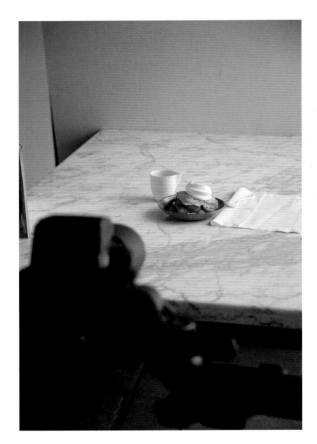

In the studio I'm connected to my computer so that the images instantly show up onscreen. This helps tremendously.

My Cup Overfloweth!

Although shooting digital is quick and easy, it has also opened up a whole new set of issues, mainly storage and file management. Luckily storage like small external USB drives and DVDs can be relatively inexpensive. My method for storing all the images I shoot for my blog or my clients is the same: multiple redundant storage on a few devices, archived to DVD and kept offsite.

Postprocessing

When it comes to digital imaging, I've learned in my 20 years of using Photoshop that there are a million ways to do the exact same thing. For the sake of this book, I'm going to keep things very, very simple. Yes, you make a million adjustments to your images and get lost in computer-land, but when it comes to editing my images of food I usually only adjust for three factors: color balance, contrast, and saturation.

Yep, that's it!

And because I really love to keep it simple, I can fine-tune these three qualities in a variety of programs, from Photoshop to Lightroom and any other image-editing software.

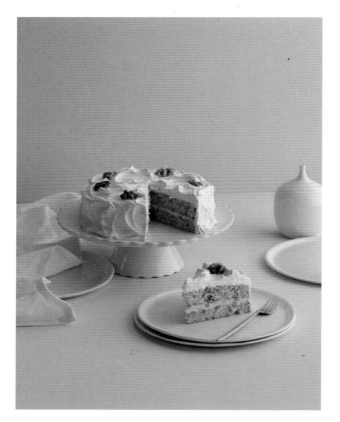 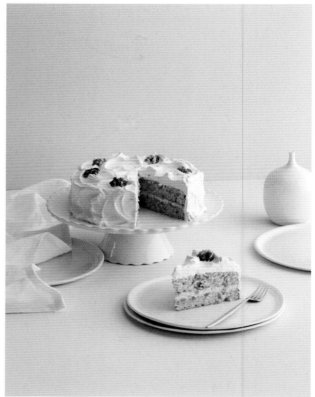

After removing a few of the blemishes and spots on the table, I simply opened the image with levels and brightness and then boosted the contrast. It wasn't much, but those adjustments took a slightly drab image and made it a bit happier.

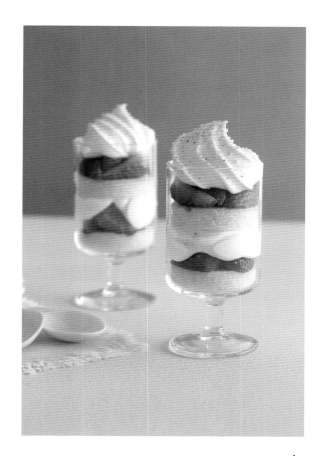 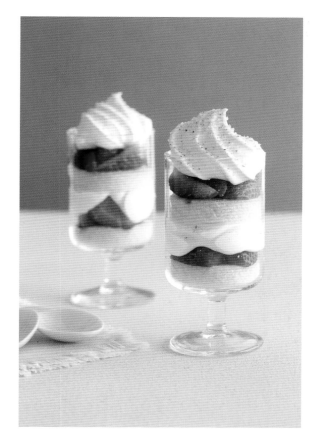

I was very happy that I didn't have too many harsh highlights and reflections on the glasses, but the colors left something to be desired. After I straightened the image, I boosted contrast and saturation to make it come to life. And remember, you can go backward, too, removing bright images and tones simply by desaturating them if needed.

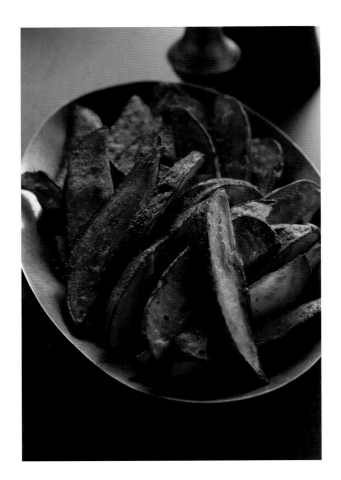
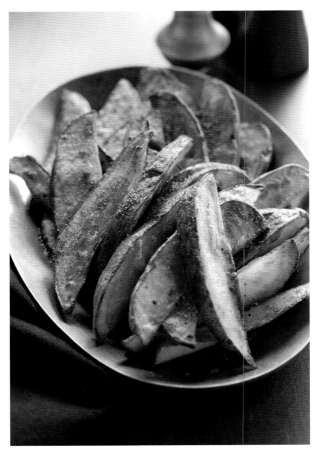

Again, these drab steak fries needed some saturating, brightening, and a dash of extra contrast.

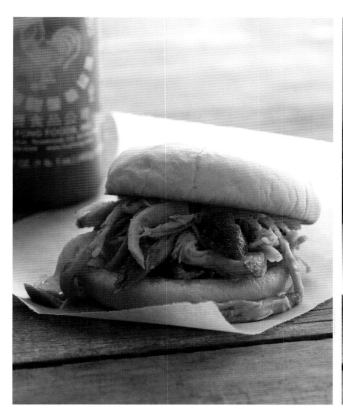 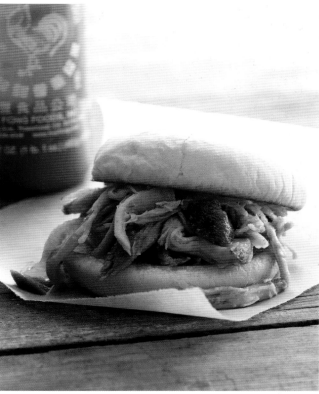

This spicy pulled pork sandwich didn't look spicy at all. It looked washed out. Boosting some basic settings gives it some appetite appeal.

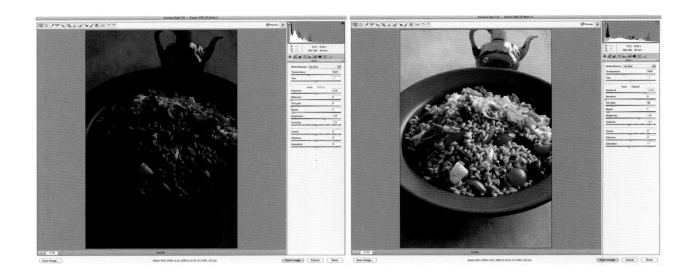

Because I shoot in a RAW format I'm able to use software to fix underexposed images like this one. And while you'll find a robust discussion of overexposure versus underexposure, I tend to underexpose my images because I know I can fix them after the fact (to a point, that is). It's really a matter of personal preference.

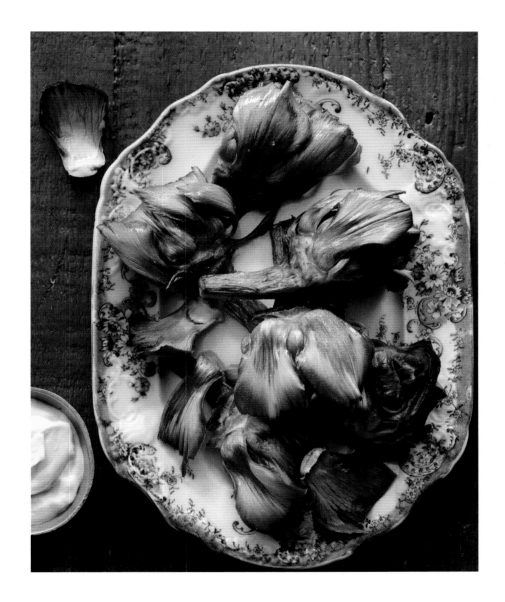

PART 2: CREATIVITY
Chapter 8: Composition

When it comes to photography I'm very fond of saying, "Everything I do lives within a very small space on top of a table." Although that's not always true, as a rule of thumb it generally is. When I say this phrase I mean that my work focuses mainly on food, and food is usually served in front of you to be consumed. Of course, this doesn't include my travel work, images of farmers or cheesemakers, and action photos of cooking, but you get the picture. Because I spend so much time photographing food, composition is critical for communicating and making my point, and I enjoy creating a story or environment within that little frame.

Photographing food may seem as simple as throwing a plate down and snapping a shot (and sometimes it is), but there are moments where one must observe, concentrate, and compose carefully. Moving a plate or cup a few inches over can create tension, intent, and drama, and, conversely, can also simplify a cluttered visual setting.

If you imagine a frame broken into sections like this figure, then you can easily see where things will fall inside an image.

The Rule of Thirds

The rule of thirds is a guideline for photographs, paintings, and compositions that sets the main object inside one third of a photo. Imagine a photo with a grid setting of two horizontal lines and three vertical lines; now imagine your subject intersecting two of the points and you'll have your rule of thirds. This is a great way to start a composition but remember, it's just a guide! Don't follow it if you don't feel like it! Because…

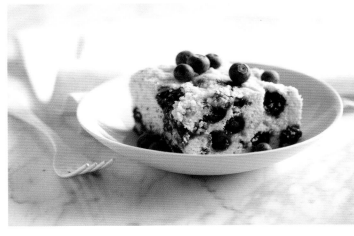

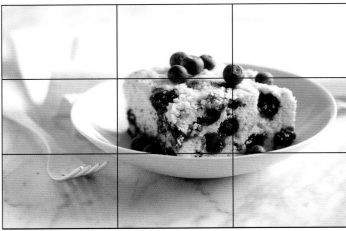

This blueberry coffeecake's main action happens in a third of the frame's position. It's subtle, but you can see how observing this rule creates a pleasing composition.

Centered

Sometimes you want to center your item for symmetry, clarity, or personal preference. That's fine, too! Centering your subject can lend a heroic quality to it.

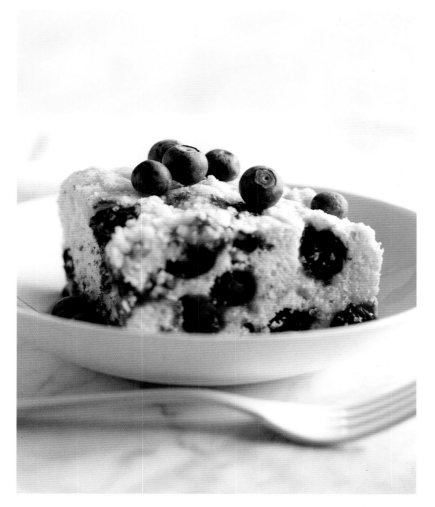

The same blueberry coffeecake takes center stage, producing an in-your-face effect.

Negative and Positive Space

Simply put, negative space is the available, empty space around your subject. In this case it's food, and negative space can be used to isolate a dish, draw focus to it, or create emotion and drama. The positive space is considered to be the subject itself, and it works in conjunction with the negative space.

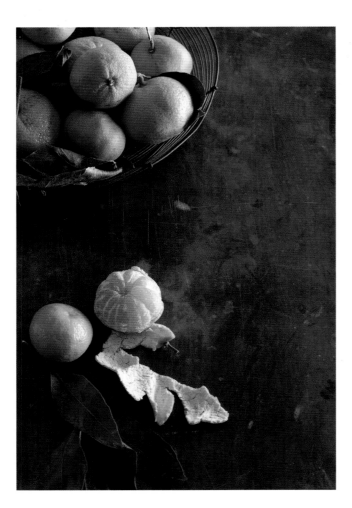

I wanted to really emphasize the negative space in this photo by placing my oranges only on the lefthand side of this frame.

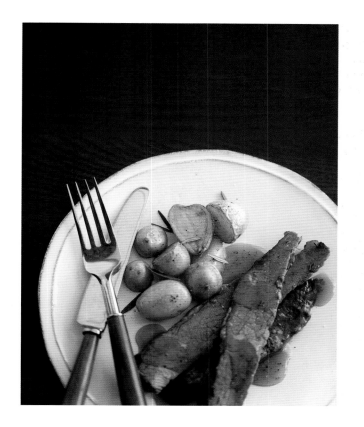

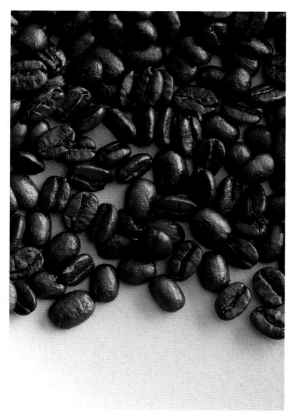

I gave this meat and potatoes shot a negative space treatment, not just for visual impact but also to allow space for copy (the letters and story that sometimes go over a photo).

The theory is inversed here, with the coffee beans used to fill up most of the frame as positive space and just a little bit of the table as empty room.

Don't Get Close Up!

Sometimes getting too close to a subject eliminates all the information and details our brains need to form a cohesive image. Without a bit of space and information, we can't really tell if that strawberry is resting in a basket or on a shortcake, and if you're including a recipe for strawberry shortcake, then you can see where I'm going with this. Allow some space and environment for context.

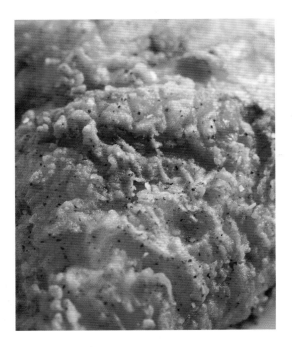 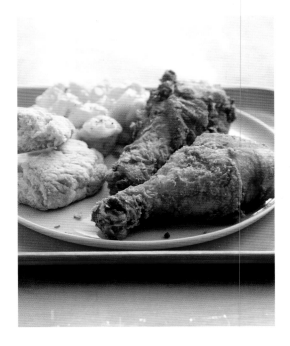

See what happens when you get too close? While you see the amazingly detailed texture of this crunchy, crispy fried chicken, you also can't really tell what it is without seeing the image on the right of the plate. Without context or additional images to support it, it might as well be the terrain of an outer space planet—hopefully one that serves fried chicken.

Or Do Get Close Up!

Forget everything I said in the previous paragraph. There are times where you may want to forget everything else but a single ingredient or dish, and in those cases feel free to get close. Maybe there's detail on a raspberry you want to focus on, or a beautiful artistic garnish in a cocktail. Again, we're just working on the opposite principle of what I discussed earlier. And in the spirit of full disclosure, this works great when your kitchen is an absolute mess! No one will ever see it.

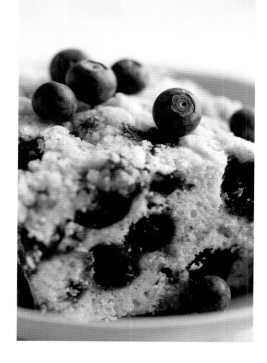

Getting close lets the viewer see detail of the blueberries as well as the fresh crumb of the cake.

Rules Are Meant to Be Broken

It's important to know the rules so that you can break them to the best of your ability, so experiment with these guidelines while you also practice their opposites. Again, this is a digital workflow, so you can photograph as much as you want! I'm a big proponent of just playing around for experimentation's sake.

Angles and Perspectives

There are three main perspectives you can use as starting points when photographing food. In fact, in the studio with clients we begin many shots with this conversation.

Overhead

Shooting your food from directly overhead creates a very graphic presentation. It's an excellent way to display the shape of the plate as well as the food, but it doesn't always allow the viewer an opportunity to see the height and construction of a dish. Although a pizza will always look beautiful photographed overhead, the same cannot be said for a hamburger, as a rule.

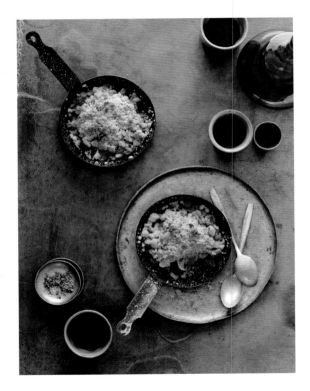

Looking down on food is a great way to capture everything happening in a scene.

Horizon or Level

This angle involves being level with the food and shooting directly into it. It works great with sandwiches, hamburgers, constructed desserts, and drinks. It doesn't work too well with a bowl of soup, for example, unless you're really in love with the underside of the bowl. Hey, it could happen.

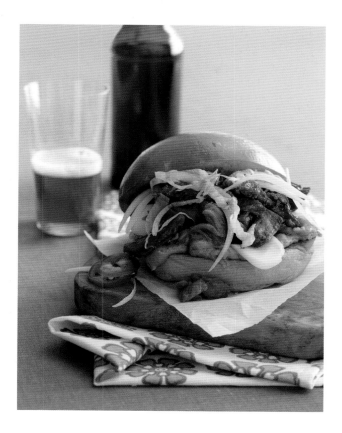

Three-Quarters Angle

A three-quarters angle features food photographed between a horizon or level angle and overhead. In a sense, it's the best of both worlds and works with so many types of food and dishes. It allows you to see the side of the recipe and the top (think three-layer cake with a beautiful ornate frosting), with plenty of wiggle room for moving higher or lower.

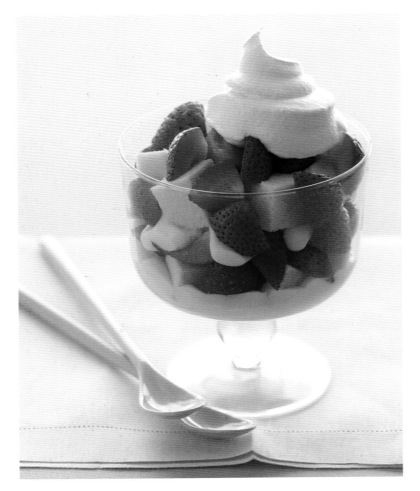

We can see just about everything important from this angle: the pudding at the bottom, the fruit in the middle, and the dollop of whipped cream on top. The only thing you cannot see is my mouth eating it, which happened a few seconds after I took the shot.

The Same Thing, Seen Differently

It's not unusual for me to switch between angles until I find something that works. It's also not unusual for me to snap a few different versions, as I don't always know how I will use them or how they'll be used by a client.

Here are a few examples of seeing the same thing in multiple ways.

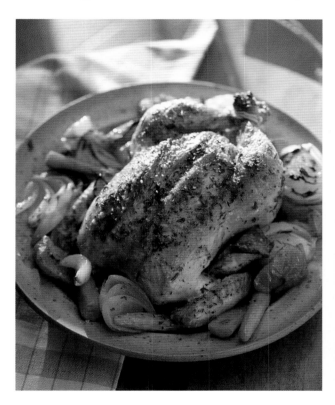 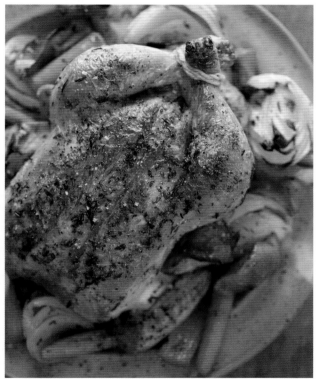

I switched between two angles as I photographed my dinner. Both convey the same message of a warm, freshly roasted chicken with carrots and apples, but from two different angles.

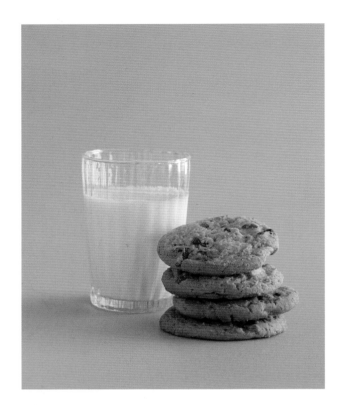 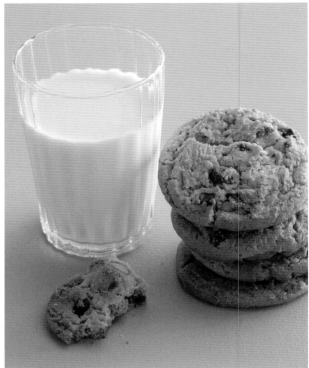

It's a matter of preference between cookies photographed with a level horizon angle or those shot with a three-quarters angle and just a tiny bit closer.

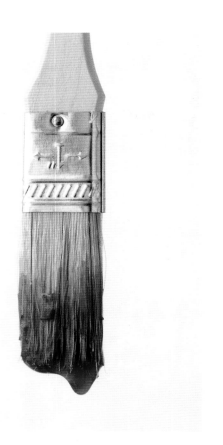
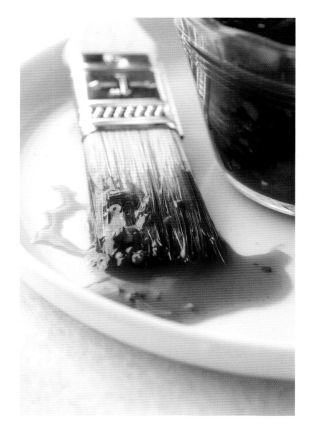

Same barbecue brush with sauce, but shown from different angles. And varying the perspective can change the viewer's perception significantly, too. The three-quarter image looks like we froze the cooking in action, whereas the horizon version makes the brush heroic and stand alone.

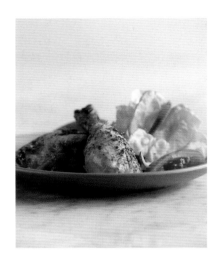 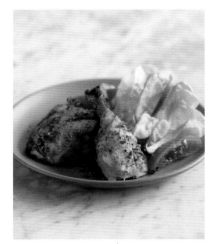 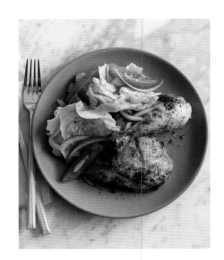

You can begin to see (or not, actually) what happens to plated food as you change angles.

I Can't Hear You! What Are You Trying to Say?

I ask students and fellow bloggers the same question when they seek advice: What are you trying to say? Everyone has a voice and everyone has a viewpoint. It's this viewpoint that can be translated into the picture frame to make each shot unique. Do you blog about the intricacies of baking, the steps required to craft that perfect croissant? Then you'll want to remove visual clutter and focus solely on the steps involved. Or are you a cook who creates memorable feasts for friends and family? Then go for quantity and breadth in an image! Of course, if you are trying to say absolutely nothing and remain as quiet as possible with an image, simple is the way to go. Even saying nothing is saying something!

HORIZONTAL VERSUS VERTICAL ORIENTATION

When do you switch your camera around and go for a different orientation? There's no rule that's set in stone. It's all a matter of preference, but as food bloggers we should always keep in mind our images' final location and use. Some blog templates work best when they feature horizontal images, whereas others work best with verticals. It's up to you.

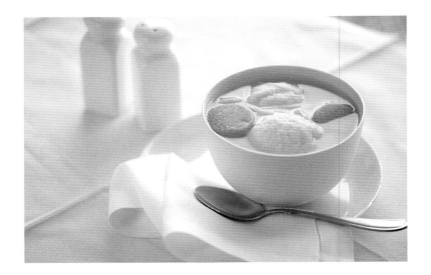

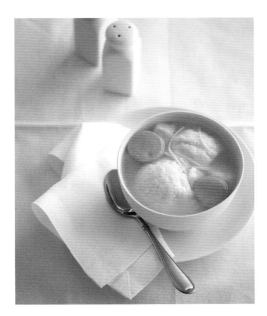

Chapter 9: Challenges and Difficulties

From years of workshops and working with students, I've noticed there are common challenges and difficulties that all of us face as we begin photographing food. Some are easy to overcome; others require practice. But because all of us have been eating all of our lives, we're already semi-experts on the topic!

I bet you didn't think of it that way, right?

Q: All my photos are blurry.

A: When there is not enough light, the camera's shutter must stay open longer. Trying to hold a camera for a longer exposure is extremely difficult.

Solution: Invest in a tripod. I'm serious.

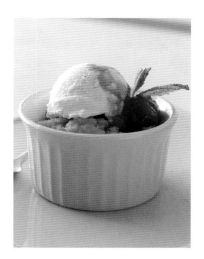

There wasn't enough light to handhold the camera at my desired settings, which resulted in blur. A tripod made all the difference.

Q: My photos look washed out when I use flash.

A: That's because you used a flash.

Solution: Don't use a flash.*

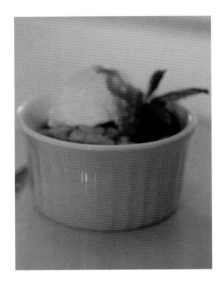

Q: My food photos never look like the ones I see in magazines. I'm defeated.

A: Pick your head up, lil soldier! Remember that most of the images you see in books and magazines have been created by a team of professionals who have worked in their field for years! Realistically you might not be able to achieve that look right now, but that doesn't mean you shouldn't try your best. Keep shooting and you'll end up with something great.

Solution: Keep shooting, practice every day, and don't compare yourself to others! You're a beautiful snowflake.

Q: I can't/won't/refuse to use motor oil to style my food because I must eat it. Therefore, it will never look perfect.

A: Hogwash! Most food photography today is done with real food using edible tricks, and the belief that we use motor oil and paint comes from the days of film and Polaroids (the food had to sit for hours!). Besides, imperfect food is beautiful—crumbs, spills, and all.

Solution: Don't make yourself crazy by striving for perfection. Just do you. Trust me, it'll be beautiful.

Q: I don't have beautiful sunlight or I photograph and blog at night.

A: There are many ways to take care of this problem, and the solution doesn't need to be tricked out or expensive. See the chapter on lighting.

Solution: Invest in a good lamp, some light modifiers, and get busy!

*Our little happy dessert from the previous page ends up looking mighty sad. *Using a flash is difficult and I don't recommend it.*

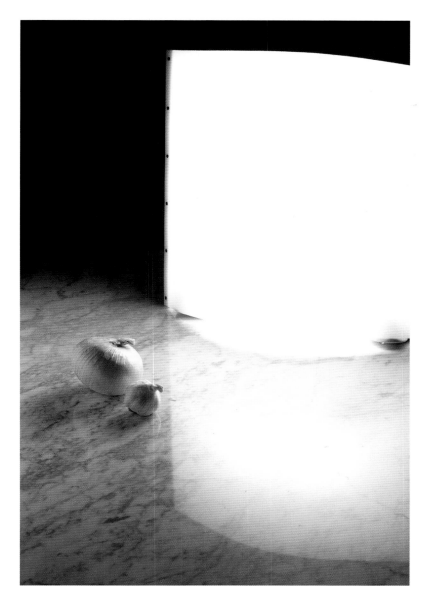

I'm really a big fan of the Lowel Ego lamp for nighttime or dark conditions.

Q: I'm no chef. I'm not even sure I could style something beautifully.

A: But you cook, right? I've come to realize that people who cook are some of the most generous souls on the planet. I'm serious. Think of the calm, love, and satisfaction you feel when you're in the kitchen cooking, and let that guide you when taking photos of your food. It'll show.

Solution: Again, be yourself and everything shines.

Q: My kitchen is literally the size of half a shoebox. A size 4 shoebox. I don't have space for all of this stuff.

A: Look, if you have space to cook, you have space to photograph. Besides, you don't need a large amount of space to photograph your meal or to create a compelling photo.

Solution: Use what you have and be creative. Tight compositions and overhead angles can be your best friends in tight quarters!

Both of these images were created on boards that measured no larger than 12 by 12 inches. You don't need lots of space to photograph food!

Q: I take horrible photos.

A: No, you don't. You're just working without a simple set of best practices and some skills,

that's all. Learn a few things and you can create beautiful images of food, too!

Solution: Never be hard on yourself. It's only food photography.

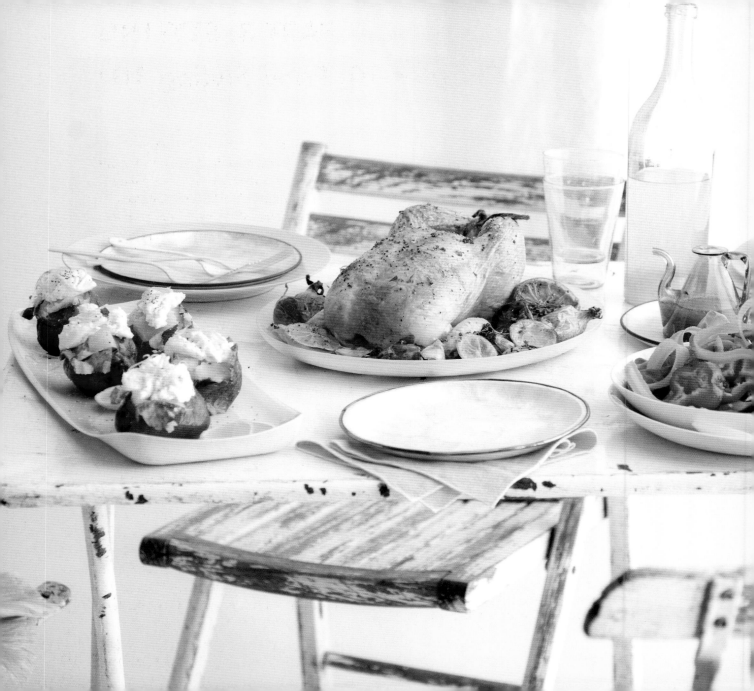

PART 3: STYLING
Chapter 10: Food Styling 101

If food photography is the star of this book, then consider food styling as the silent, behind-the-scenes co-star that can make or break the movie. Without it, professional food photography wouldn't exist. Or at least it wouldn't look the way it does currently.

Food styling is a craft that balances art, cooking, creativity, and problem solving. In more simple terms, it is the preparation of food for still and motion photography. Movies, magazines, television shows, you name it—if there's food in it, it's most likely been prepared by a professional food stylist. But just because these images are created by a team of professionals doesn't mean you can't have gorgeous food imagery of your own. You absolutely can.

Back in my old art director days, I would spend hours with food stylists on sets. I was mesmerized by the culinary alchemy they achieved, using unorthodox gadgets as kitchen tools that resulted in food that appeared perfect and long lasting. They'd use dish soap as a glaze, spray paint on roasts, and use lipstick on fruit to make it absolutely perfect. And because we were using film, it had to be. The process took longer as you waited for the photographer to load Polaroid film, snap a few shots, wait for them to develop, review, then watch the photographer replace the camera back with a film magazine and do it all over again. It was a tedious process that made food photography a bit more complicated than the process we know today.

With the advent of digital photography, we've been able to get rid of that waiting game, snapping as many shots as we want without wasting time or expense. Of course, this has its own issues (Work faster! Let's try another version!), but for the most part it's a welcome change. One of the biggest changes occurred with food styling itself: food was no longer required to sit for hours as photographers perfected their lighting setups. It became as easy as placing a stand-in on the set, getting things ready, and then snapping a few frames once the final plate (often called

a "hero") was ready. We didn't need a turkey to be lacquered to high heaven or a burger to be made up of fake ingredients, as the real deal was just fine. It's a philosophy I can easily get behind.

Granted, it wasn't just technology that facilitated this change but also how we see food today. We no longer needed it to appear flawless but became willing to accept its inherent flaws. The crumbs and spills became beauty marks, the imperfections perfect. Of course, this is really the oversimplification of a bunch of factors (the return of cooking and loss of the nuclear family, the modern movement of organics, seasonality, and local eating), but as bloggers this has all worked in our favor. We now have access to the same food and technology, and it has resulted in a much more level playing field. As I said

earlier, everything we need to create serious and beautiful food photography is at our fingertips.

I'm going to step out of the professional photography studio and into the kitchen to explain how many of the best practices apply to all things regarding photo styling. I'm also going to tell you that none of this advice can take the place of working with professional food stylists, as they are indeed masters of their craft. And for the record, I am not a professional food stylist but I happen to be married to one. I just have an insider's scoop, don't ya think?

Food Styling Best Practices (as They Relate to Blogging)

5. Edit your plate.

4. Less is more.

3. Be creative with garnish.

2. Scale.

1. Think outside the plate (use environment and props).

5. *Edit your plate.* Do you really need to show an entrée, three sides, and one salad all on a single plate? This may whet our appetites as we sit down to eat, but visually it becomes jumbled and hard to understand. I suggest two or three things on a plate, incorporating practice 4 below. Who says you can't take more than one photo? Save some stuff for another setup.

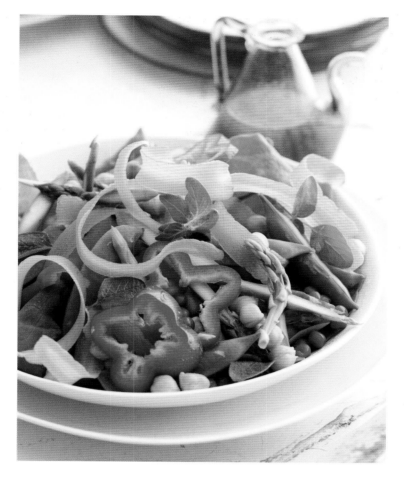

Originally this salad was to be shown on a plate with roast chicken and potatoes. It was simply too beautiful (and colorfully busy) to display with other foods. The solution? A larger single serving standing alone in its own shot.

4. *Less is more.* The camera (and, thus, your viewer) has a better chance of comprehending your culinary creation when you show a smaller portion. No, you don't have to make everything you prepare look like nouvelle cuisine, but keep in mind that it's an easier "read" when you plate smaller portions, as a rule.

Being heavy handed with the portions doesn't always translate well in food photos. Rather than pile up, you can go light so that the eye has a chance to see the entire meal.

3. *Be creative with garnish.* Who says you have to use the ubiquitous sprig of mint or parsley as a garnish on a plate? You don't! Try pulling ingredients from the recipe to use as garnish. If you're making a plum-based barbecue sauce, for example, save a few slices of fruit to garnish your plate when it comes time to photograph. A tomato sauce with cooked and chopped basil could easily be dressed up by sticking a gorgeous whole stem of basil on top for the photo. Take a look at the ingredient list of your recipe and try to identify which ingredient might make an interesting garnish.

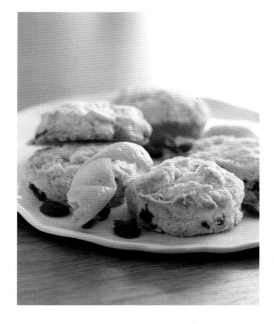

Although chopped parsley was an ingredient in this pea salad, we left larger leaves whole to garnish the dish. This is a traditional garnish and creates some variety. If you're looking for nontraditional ways to garnish, orange peels and some extra dried cranberries were used as garnish for these scones, because you can't really see them inside the baked item.

2. *Scale.* This is directly related to practices 4 and 5, and they do all work together in harmony. Generally speaking, using a smaller plate will help bring the items together and focus the eye on the food. We love smaller cake and salad plates when photographing food, leaving the large dinner plates on the table for the real eating.

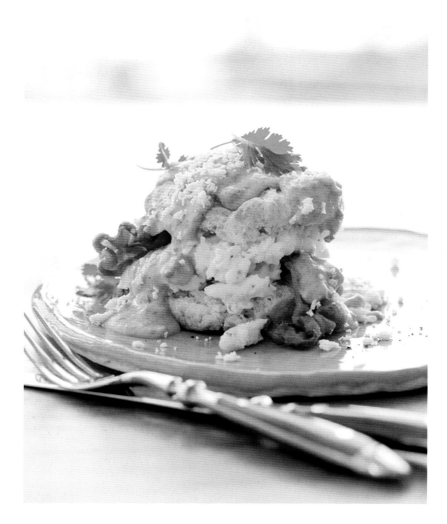

Small plates make the food look heroic and magnificent! This lone biscuit would have been engulfed on a larger, average-sized dinner plate.

1. *Think outside the plate.* Who says you have to photograph every bit of food on a plate? You certainly don't have to!

Cutting boards, pieces of kraft or wax paper, serving trays, planks of wood, napkins, and baking sheets all make fantastic surfaces on which to style your food. Be creative!

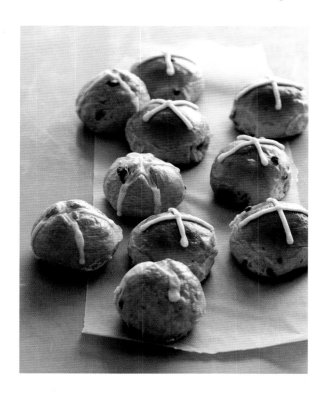

I used brown parchment paper on top of the table for these tasty treats, and even put cupcakes on a ladder. Who says you must always use a plate? I certainly don't!

Fresh is best! Starting with high-quality food yields great results, and if you make it yourself, even better. When shopping for fruits and vegetables for photography, look for the absolute freshest you can find; nothing can ruin a food image faster than bruised fruit, a dead stem on a strawberry—you get the picture.

There's not a whole lot of food styling for you to incorporate if you're photographing your food in a restaurant. The chef's already seen to that. However, sometimes moving a garnish away, taking some extra off of the plate, or even asking for things à la carte can help create a better image. Experiment with what works for you and remember, sometimes you don't want to mess or alter how it's served at a restaurant, especially if you're staying true to the integrity of the chef's dish.

USING A STAND-IN

Earlier I mentioned a hero, which is a fancy industry term for the actual final plate of food to be photographed. But when setting up a shot, we'll sometimes use a stand-in, which is a very close representation of the final project. It could be the same sized plate, a pile of raw ingredients that mimic the final dish, whatever, just something that will allow me to work on my angle and lighting before working with the hero.

Because you move pretty quickly when shooting ice cream (something about that melting thing, you know), we use a crumpled paper towel to set our framing, lighting, and exposure. When we're ready, we just drop ice cream into the glasses and snap away.

This is an average selection of things you may find in a food stylist's toolkit. However, after asking a few food stylists what's the one thing they couldn't live without, the answer was clearly a good pair of tweezers and some towels.

So what's in a toolkit? You'll find some interesting stuff in a food stylist's toolkit. They're mostly made up of household items, and stylists use these gadgets like magic wands to shape, poke, prod, and adjust food into its perfect place. Whereas some of these tools might be overkill for the home cook, other things like bamboo skewers are excellent to have on hand for lifting and moving with precision. Here are some of a food stylist's most popular tools:

- Bamboo skewers
- Brushes
- Butane torch
- Cookie and biscuit cutters, round in various sizes
- Cosmetic sponges
- Cotton balls (great to help build up food and also heated with water to make steam when needed)
- X-acto knife
- Food coloring
- Fruit Fresh Anti Browning Powder
- Garnish tools: zester, melon ballers, and the like
- Ice cream scoopers (a mix of sizes)
- Karo Syrup in light, brown sugar and dark
- Kitchen bouquet
- Metal skewers
- Museum wax
- Pallet knives
- Pam nonstick cooking spray
- Scissors
- Spray bottles
- Straight pins and T-pins
- Syringes
- Toothpicks
- Tweezers

Cooking Separately, Building Later

Although you might not go to such extremes while cooking your own dinner, the practice of cooking food items separately and then assembling them for food photography is common-place. It allows the stylists to assemble the various ingredients at will, adding a little bit here, a little more there. Sauces are brushed back on, bits of veggies are added to fill a space—you get the picture. A perfect natural example would be a hamburger, and yes, that's a steam iron being used to melt the cheese!

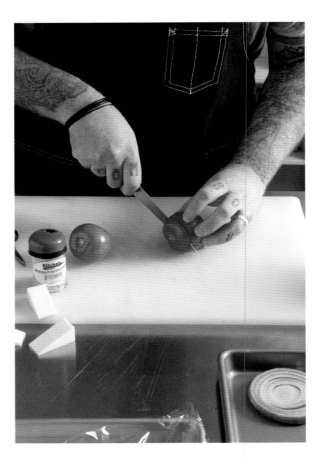

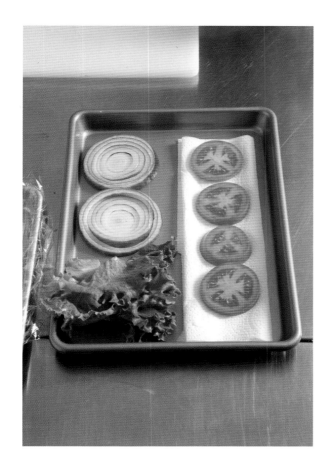

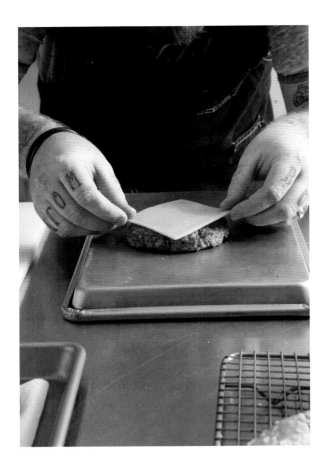

 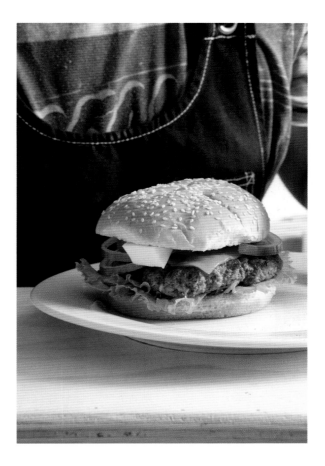

Each component of this burger was perfected before assembly, and space was made in the top of the bun so that it would rest perfectly on top. A cosmetic sponge was used to wedge the bun forward. You can see the final burger on page 141.

Chapter 11: All about Props

Props, which are just about everything but the food, communicate and set the scene, playing an integral part of the final image. They can compliment or detract and deserve careful thought and selection.

Just like still-life images painted during the renaissance, food photographers have relied on plates, fabric, and cutlery to instill a sense of place inside a photograph. These are what we call props. Used effectively they can add color, movement, and shape to images, but the opposite holds true, too: used improperly, they can clutter and detract.

Considering the food we eat is usually served in or on something, props figure prominently in our work. The correct use of a picnic plate and red gingham napkin can signify to our readers that we're talking about summer, and they'll get that sensation without having to pack up and head to the park. The use of color in a photo can also provide dimension, adding more to the story than just the food.

Of course, keep in mind that we may not always want a table setting to distract from the message, whatever it may be. A set of instructional photos about making a cake wouldn't be well served if it included a million props around it, just like an architecturally built dessert is sometimes best standing on its own.

You don't need a million plates and access to a prop house to add variety in your food images. I've compiled a list of prop ideas that save not only time and money, but also space (which can be a huge concern in many of our already cramped kitchens).

Plates and Bowls

Having a selection of white plates, saucers, and bowls on hand is a

fantastic way to start. Food almost always looks good on white, and it's easy to dress up or down. When I began building my prop room, I made sure to have a variety of white plates on hand, and they're still in use years later.

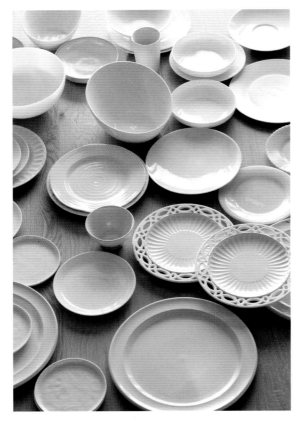

You absolutely cannot go wrong with white plates and bowls. In fact, if I could use only one color, it would be white. It's extremely versatile and lets the food shine.

When it comes to color, I try to work my way through the rainbow by having a few plates and bowls of each color on hand. I tend to prefer lighter colors like yellow and green, for two reasons: they're natural color pairings with food and easier to light when photographing them. A shiny black plate comes with its own set of problems, you know. Having said that, don't be afraid to use darker, deeper colors like browns and dark blues.

And when it comes to shapes, experiment with a variety to see what you like best. I find it much easier to frame round or oval plates, but this is only a matter of personal preference. A quick note about patterns on plates and fabric: Use judiciously!

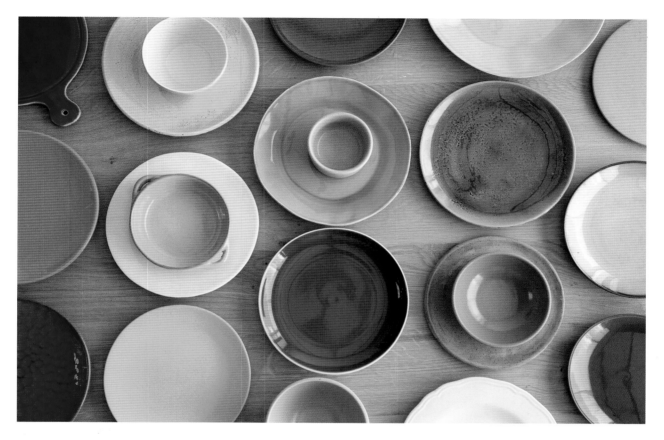

I keep simple plates in many colors on hand to add a splash of color to a food photo. I prefer unadorned and unpatterned as a rule of thumb. Also, don't forget that neutral colors like sand and off-white work great in food photography, too!

Fabric

I once had a student complain about a very dated, avocado-green 1970s countertop throughout her kitchen. She lamented that everything looked the same when she photographed her food for her blog. I suggested fabric, and the little lightbulb went off in her head. When you think of it, there's no easier way to change a tabletop or counter than with fabric. Drape it, put your food on top, and snap away! In the studio we use it frequently to immediately change the set, and it can be a relatively inexpensive way to go.

You can visit thrift stores, yard sales, and fabric stores to find swatches and yards of fabric. Napkins can work too if they're large enough. Sometimes one half or one yard is sufficient, depending on how much coverage you need. When you're done, you can easily fold up the fabric and store it in a drawer or a bag.

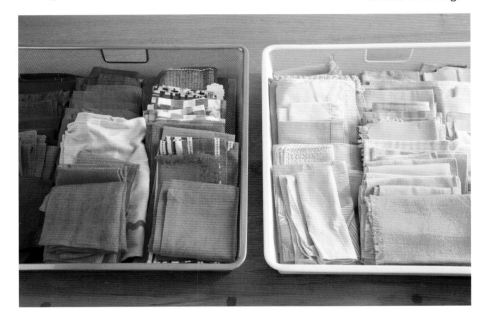

I keep napkins arranged by color in easy-to-reach bins. Some of them are large enough to become tablecloths in front of the camera, too. I don't have much use for sets or multiples when it comes to napkins; that makes storage relatively easy!

Surfaces

When it comes to surfaces, you can use anything. The camera will only see a small portion of the surface, so it's easy to get creative. Tile, painted pieces of boards, or even 2 by 4s make excellent table surfaces. I even keep a collection of matte boards from a framing store on hand because they are available in so many colors.

I also love using cutting boards and pieces of wood as a base underneath food. This works especially great for baked items and desserts. I always keep my eyes open for great pieces!

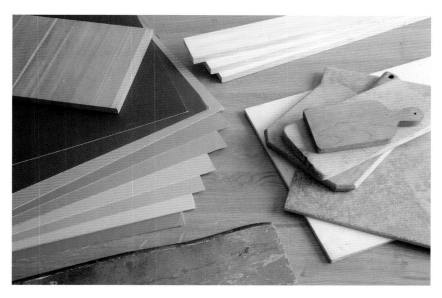

As you can see in this photo, I really dig using large poster board as an easy way to create a surface. They make great backdrops, too. Large tiles found at home improvement stores work well, as do pieces of board and 2 by 4s. A quick paint job can easily change a painted surface into the color of your choice. And don't overlook old, distressed pieces, either; they can add quite a bit of texture to an image.

Glasses, Cups, Cutlery

Just like plates, these things add dimension and establish a sense of place inside a photo. I always keep my eye out for interesting glassware and find that because it's for photography I rarely need an entire set of anything. Thrift stores and eBay are great places to find these kinds of items. If you photograph drinks or desserts often, you'll realize the importance of keeping a variety on hand.

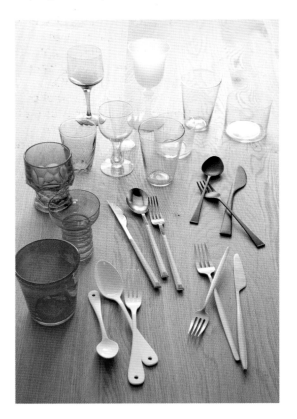

Fabric Tip

Using a piece of pressboard or particle board and white felt underneath your final fabric selection helps protect your surface and keeps the fabric smooth.

Because I'm not just ironing on an ironing board but on the actual set, it really comes in handy. I definitely recommend this tip!

Small glasses work well for food photography so I keep many on hand, always in a variety of shapes and heights. And though I'm a big fan of clear glasses, I love adding a splash of color to an image with a colored glass. When it comes to flatware, I like the unusual and unique, but my everyday stuff does the trick, too!

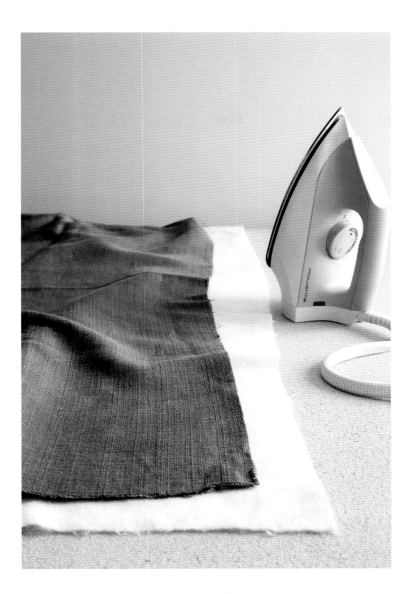

The Scale of It All

A note on scale: Although we strive for accuracy in food photography, one area that constantly surprises new folks on the set is the idea of scale. What looks perfect to the eye as we sit down at a dinner table might not necessarily work in a food photograph. Without the cues and reference points of size (a human hand, a child's bicycle in the background, etc.), that standard dinner plate might suddenly appear too big when you photograph it. For this reason we tend to use smaller dessert and salad plates as well as smaller cups and glasses. Considering you'll be editing the portions of your food and "editing your plate" (hopefully!), this makes much more sense when you look through the lens of your camera.

A few ounces of sliced chicken breast and a healthy salad appear perfectly framed on a smaller plate, but to the naked eye, this setup might appear a bit cramped. And the larger plate that might be used in a restaurant or at home makes the food appear as if it's floating on the plate, seeming a bit lonely and smaller. If your goal is to feature the food, I'd definitely choose the smaller plate.

What Are You Really Trying to Say?

What are you trying to say? Sometimes props are all we have to communicate a message or feeling inside a food photograph. Choose them wisely!

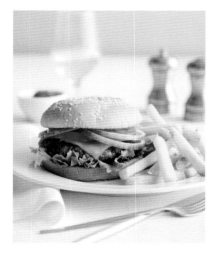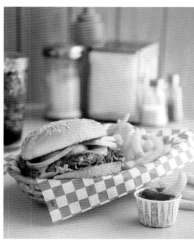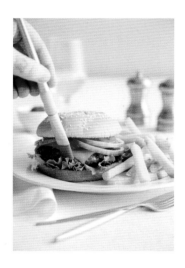

Sometimes just changing the physical props—and not the food—can make all the difference in the world. Case in point: This hamburger, seen as a little fancy bistro burger on the left (complete with knife and fork!), appears as your run-of-the-mill diner burger in the center. On the right, a quick brush of oil on the hamburger patty brings it back to life and makes it look warm again. Nope, the food didn't change, only the set. It's an entirely different message! I realize this was photographed in a studio with tons of additional props, but I'm using it to illustrate the importance of a set.

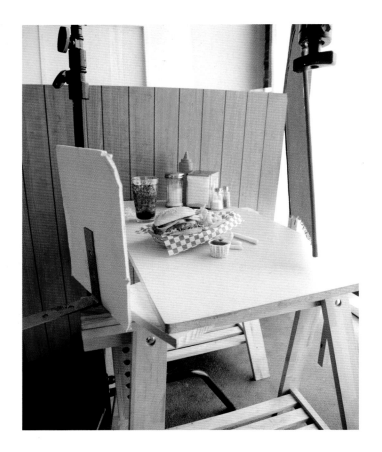

A Note on Shopping

You don't need to break the bank for food props. I'm notorious for searching clearance items at department stores as well as hitting thrift stores, and the fact that we don't need a place setting for four people always works in our favor. Keep your eyes peeled for garage sales, 99¢ stores, flea markets, estate sales, retailers like Target and Ikea, as well as friends and family. Let them know you don't mind taking that last unmatched glass or plate off their hands.

I created a slice of diner life on two sawhorses with an actual countertop piece from a diner. I had one main light source to the right and used a fill card made of foam core to reflect a little light back into the set. The black net flag was used to control some contrast.

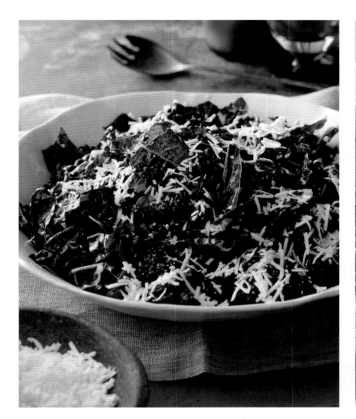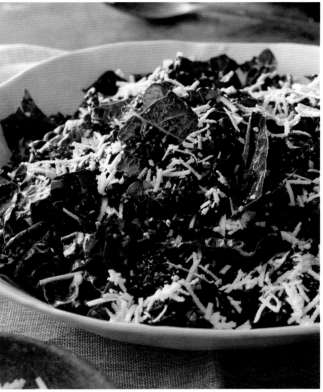

Sometimes too many props can distract! I photographed this delicious kale salad for a magazine story, but I ended up running a more tightly cropped version for clarity. Occasionally, extra things do get in the way!

PART 4: TIPS AND TRICKS: THE REAL WORLD

Chapter 12: Matt's Top 10 Tips for Food Photography

I could have easily made a Top 20 list for this chapter, heck, even 30, as I find there are so many tips that help us successfully shoot food. But then I realized the beauty of food photography: everyone eats, everyone has a voice, and technology abounds. Better to let others find those moments of discovery that make food photography so fun, fresh, and appealing. However, I had to include my Top 10 Food Photography tips; but remember, they're only tips. Nothing is set in stone, and I encourage you to discover what works best for you.

10. *Be a cook.* Know as much as you can about food. This means how to cook it, where it comes from, and how it reacts to heat, freezing, and time. This doesn't mean you need professional culinary training, just an understanding of food's properties. Did you know that some of the best food photographers I know are also excellent in the kitchen?

9. *Use natural light when and if you can.* It's always around during the day and doesn't cost a thing. But it's not easier, a phrase I hear all the time. Don't confuse abundant and free with easy. But food looks its best in natural light.

8. *Respect your food.* I don't mean that you need to be afraid of it, and I sure don't mean you can't play with it. I do this all the time! But have respect for what it took to make its way to your plate, consider waste and how fortunate we are to have the luxury of time and enough food to photograph. Many the world over should be so lucky.

7. *Fresh is best.* When food is the subject and it's front and center, it pays to use the freshest you can find. Fresh food is beautiful food.

6. *Be yourself, enjoy the process, and share your story.* Considering we all eat (I hope), we are all experts on what tastes good to us and what we enjoy eating. It stands to reason then that any food photograph you make will be unique and individual. Make sure to let your personality and story come through with your photo. And because we're blogging about it, make sure to share *you*. After all, that's why we're here, no?

5. *Do not use flash in a restaurant to photograph your food.* Don't. Don't do it. Ever. And don't let snapping your dinner photos ruin your meal or the meals of your fellow dining companions and those around you.

4. *Reach out. Ask questions. Take notes. Be inquisitive.* Thanks to this thing we call the inter-webs, we can reach out and ask many questions. Find someone you admire, send an email to someone who inspires you. Share your ideas and ask questions. The worst that could happen is the person doesn't respond. And this goes both ways, people. If someone asks you a question, do your best to accommodate him or her. Let's pay it forward, shall we?

3. *Take your time and learn from every mistake.* Creating food photos takes exercise and discipline in order to improve.

2. *Leave your comfort zone on occasion.* Pastries, desserts, and beautiful fruits and vegetables will always be there to photo-graph, but challenge yourself with something you might not normally cook or photograph. This is where the magic (and growth) can happen!

1. *Ignore the rules and make them up as you go along.* Yes, I realize I'm contradicting myself, but rules were made to be broken, no?

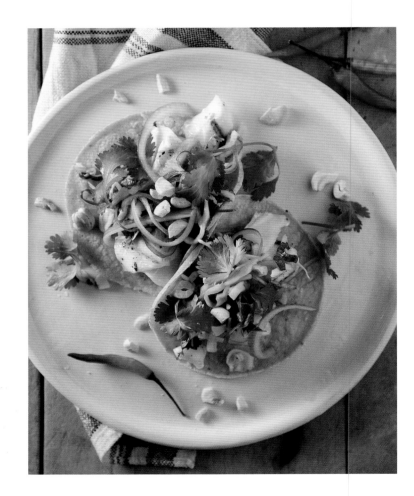

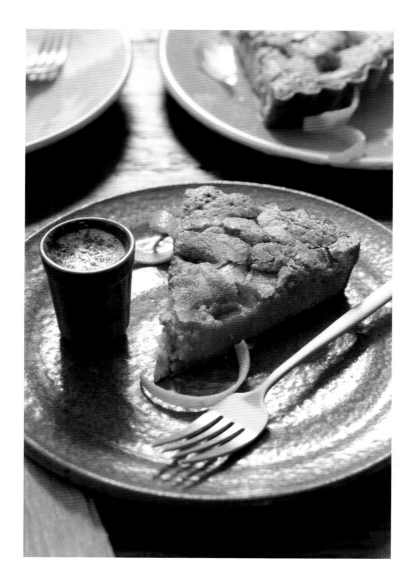

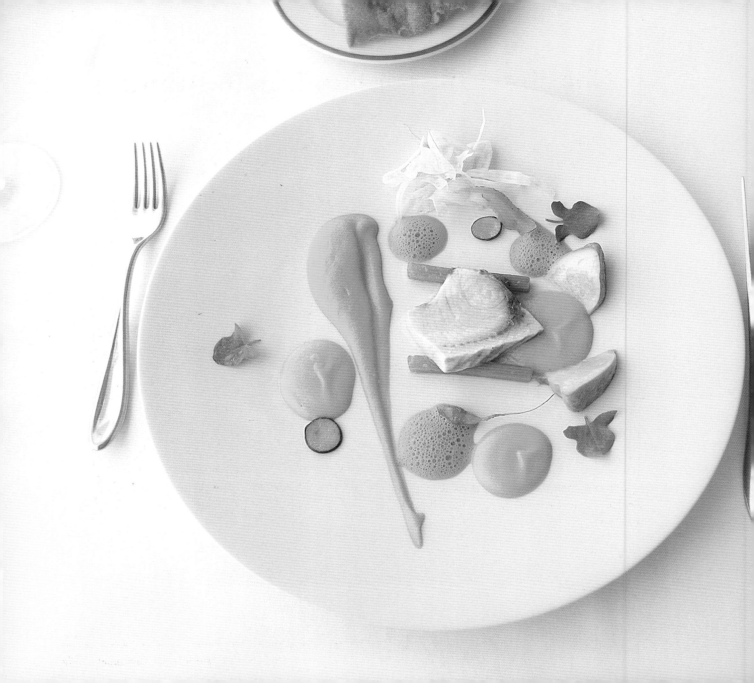

Chapter 13: Shooting in a Restaurant

So why is this a short chapter? To be perfectly honest with you, it's because when it comes to shooting in a restaurant, your choices are limited, folks. That doesn't mean it can't be done. It totally can be. It's just that there are no secrets or magic tricks when photographing your food in a restaurant. You're at the mercy of a million little factors that are usually out of your control, and you must do your best with what you have.

Then again, there's nothing wrong with that.

But if you are indeed photographing your food in a restaurant, it's best to keep a few things in mind when doing it.

Location, Location, Location

If possible, ask to be seated next to a window or in an area where you'll have ample light.

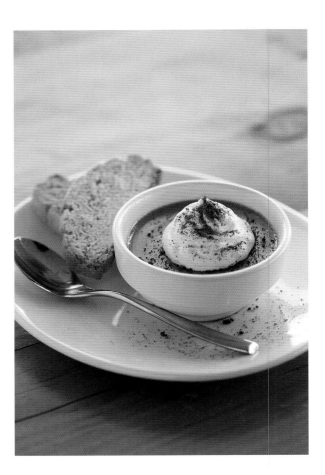

For this assignment for Coastal Living magazine, I arrived during the day to photograph a series of drinks and entrées. Just so you know, my approach remains the same whether I'm shooting for myself or a magazine. Now where's that window?

Arrive Early

If I'm totally set on photographing the food in a restaurant, I'll make sure to arrive early or go for lunch. This guarantees that I'll have natural light for the best photos.

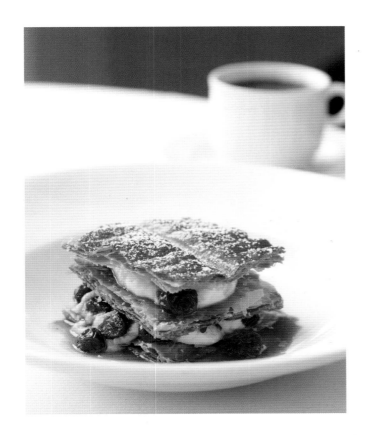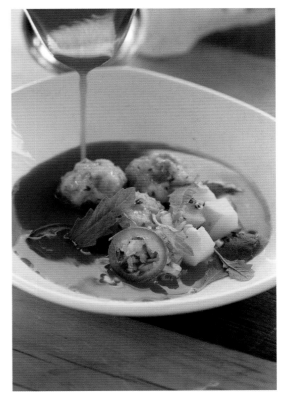

I made sure I arrived early to take advantage of an emptier dining room and better light, and it's much easier to get the cooperation of your server when they're not rushed.

Ask

Unless you're super stealthy, it might serve you well to ask the chef, a server, or the general manager if you can photograph your food. Many restaurants have implemented "No Photography Allowed" policies and actual bans on photography. Remember, you're in their place and must follow their rules if you want to be a gracious guest. And, of course, you do, right?

Asking can also open many doors, too. Many chefs are delighted and welcome the exposure, and I've seen restaurants go out of their way for bloggers so that they can get the best snapshot possible. (A certain restaurant chef's wife even bought a light tent so that bloggers would have enough light at dinner!)

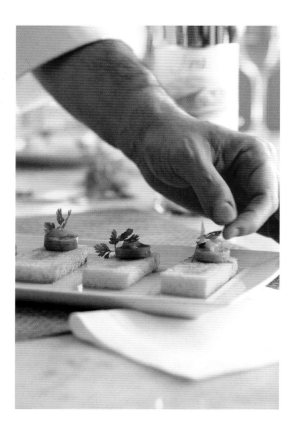

Who knows? If you ask, the chef he might allow you access to a few key behind-the-scenes moments you might not have gotten otherwise.

Use a Fast Lens and Bump Up That ISO

If you're shooting with a dSLR camera you can use a fast lens that allows more light and you can also bump up your ISO. ISO is a camera setting that allows more light to hit the camera sensor, but it also causes a noiser image.

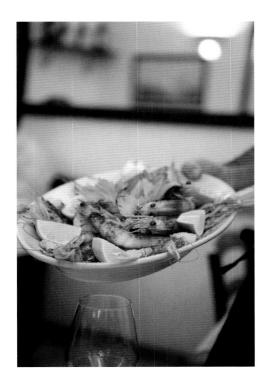

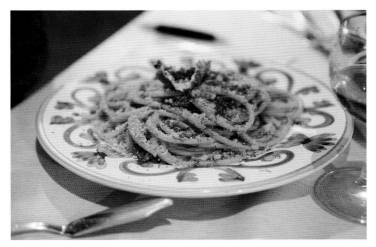

These shots required a fast lens and high ISO, and even then the light was nowhere near optimum. Then again, I was eating my way through Rome when I took them, so I'm not complaining.

It's Okay to Ask for Help

In this case I mean help in the form of a postprocessing application. You might need to get some help reducing noise, brightening an image, or changing an underexposed image if it's been photographed in dark conditions. There's nothing wrong with that.

I've been known to convert very poorly lit or colored images into black and white when needed.

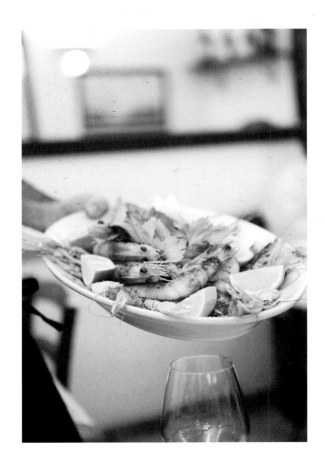

I don't generally recommend black-and-white food images, as color plays a large part in food. However, it can work in a pinch!

I Hate to Nag, but No Flash, Please!

Why no flash? The food looks harsh, the depth is flattened, and you end up with a very unflattering photo. On top of all that, you might end up bothering those trying to enjoy their meal at the restaurant. My advice is to skip the flash and try shooting the photo with the flash off. Experiment with different modes on your camera and be aware that some of the finest restaurants around actually have no-flash policies!

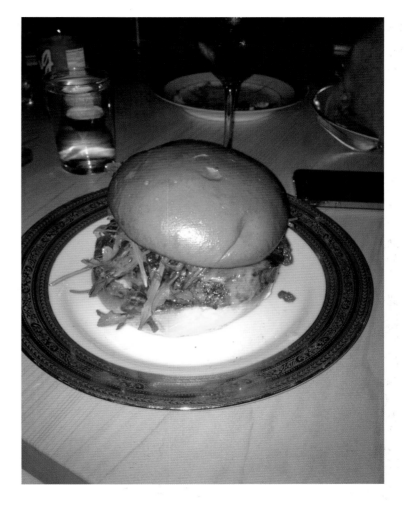

I broke my rule and used my flash on my iPhone to photograph my burger as an example. As delicious as it was, this photo doesn't do it any favors whatsoever. Yuck.

I'm a big fan of twilight and happy hours, the moments just before it gets dark. There's enough ambient light to fill a room while letting a restaurant's candles or lighting accent the image. This round's on me.

They say that necessity is the mother of invention, so don't laugh when I tell you that I've been known to hack ping-pong balls and flash modifiers to work with small flashlights that I carry with me to a restaurant. Is it enough to light an entire entrée? No. But it can be enough to add a bit more light to a plate without using your flash. And it's a cheap thing to do, too.

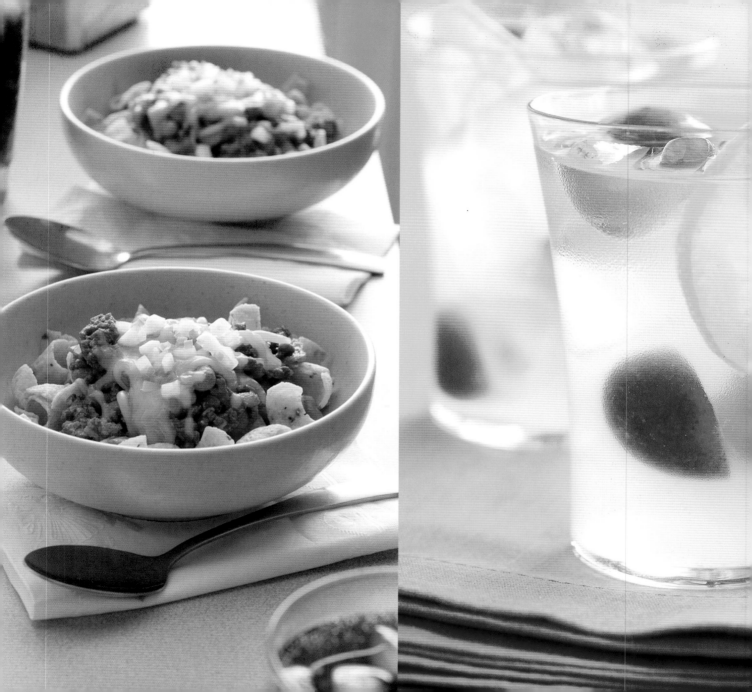

Chapter 14: Difficult Foods to Photograph and What You Can Do About It

I recently put up a survey on my blog and through Twitter asking people to share with me the foods they found the most difficult to photograph. Out of the several hundreds of comments and emails I received, the same foods kept appearing over and over again, creating a list of things that even I don't relish photographing. And what were those things?

Soups. Bland foods. Rice. Casseroles. Stews. Wet things. Soupy, gloopy, sloppy things. Brown things.

First, I feel your pain. Although some foods like a gorgeous bowl of bright Satsuma tangerines are beautiful as is, certain foods need quite a bit of coaxing to bring out their beauty. And as professional photographers it's our job to do so.

Surprisingly, keeping a few key practices in play can make all the difference in keeping that bowl of Saag Paneer from looking like a brownish green blob.

Soups

Soups were number 1 on the list of difficult foods to photograph. And you can see why. Think about it. Soup consists of little pieces of things floating in liquid that's susceptible to glare and highlight, or dark chunky brown things sinking to the bottom of a brown liquid that, yes, is also susceptible to glare and highlight.

But here's the thing. Overcoming soup's challenges means you'll never again struggle with stews, porridges, or dips. Generally speaking, they all have the same challenges when it comes to photography, and once you learn to control them, you'll no longer struggle.

By using one main light source, in this case a window, I've positioned my soup to show what happens when you back-light it.

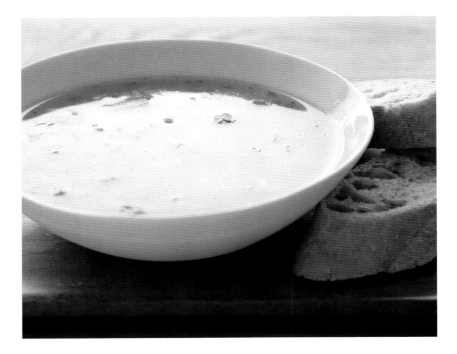

CLEAR SOUP

CAMERA

As you can see in this photo, the food has been unstyled and the only thing the eye sees is a big white oval reflection. No amount of propping can change the fact that you absolutely cannot see what's in the soup. How can we fix this problem? Let's move the soup.

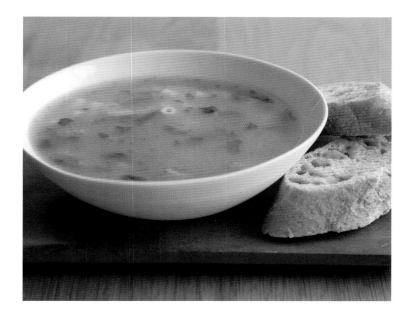

WINDOW

CLEAR SOUP

SMALL FOAMCORE

CAMERA

In this image we've moved our camera and subject so that the light source is to the right. Now that the lighting has changed direction, we're able to see the soup in its entirety without the big white oval reflection. We're getting close, but we're not quite there yet.

We're back to our backlighting angle, but this time we've taken the ingredients of the soup out of the bowl, rinsed them off, and then placed them back on top of the soup, making sure to have enough other ingredients in there underneath so they don't sink. In this case, the food styling makes all the difference.

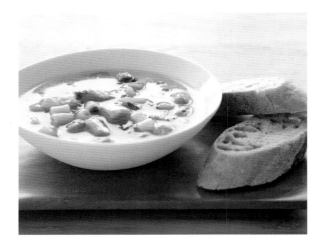

WINDOW

BLACK
FOAMCORE
ABOVE SOUP

CLEAR SOUP

CAMERA

Although I like this angle, I still feel the reflections are a bit too strong and distract the eye. Here's where a simple piece of black foam core comes in handy. Held out of the frame, it actually blocks the light from hitting the soup, allowing us to see the top of the liquid and all its delicious contents.

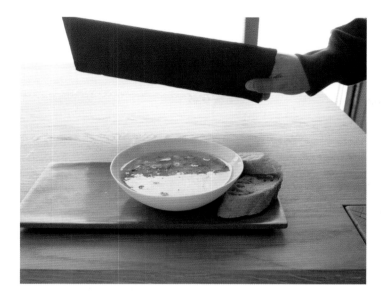

Here's the same shot with the card moved back a bit, letting me actually control the highlight and reflection. Nifty, right?

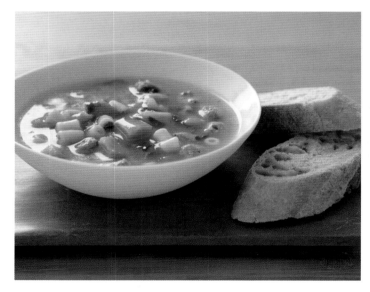

And just for the heck of it, this is what the soup looks like when moved (along with the camera) to between these two spots. Personally I like the reflection and lighting on the top of this soup best. There's a lot of activity in there, and for soup that's a very good thing.

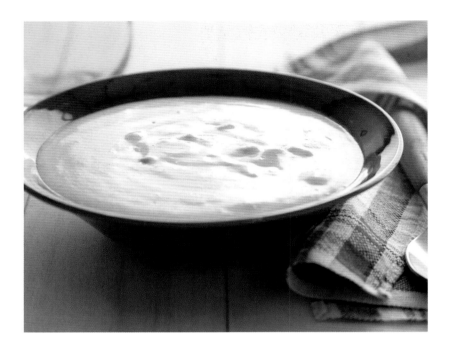

Here's a big bowl of hearty chowder, otherwise known on set as a big white blob. Because I already know I'm happy with sidelighting and that the surface of this cream soup isn't as reflective as a clear broth, all I need to do is have it properly styled in order to communicate its ingredients.

I like the propping and the fact that the blue signals the eye that this is a potato and seafood chowder, but I still can't see a darn thing inside the soup. That's no good.

WINDOW

CREAMY SOUP

SMALL FOAMCORE

CAMERA

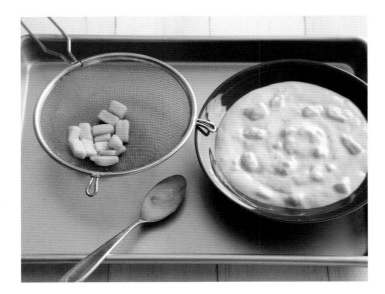

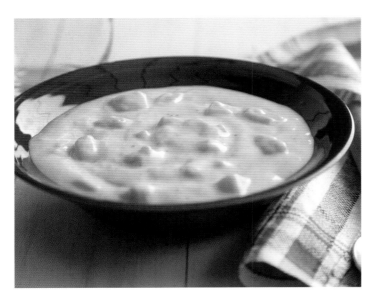

This is a basic food styling technique that is used for soups, stews, stir-fried dishes, and the like. Small pieces of ingredients are removed, given a quick rinse, then carefully brushed with the broth, liquid, or gravy they were cooked in. They're brushed with just enough so that it covers them without obscuring their color or shape. The best part is that this is a completely edible food tip that doesn't sacrifice or waste your food. And if you mess up you can always start over!

Here's the final image with the chunky pieces of potato placed back on top after a slight brush of the creamy soup. There's now shape and texture in what was plain and white before.

Another common response to my difficult foods question was anything bland in color and shape. Biscuits, mashed potatoes, rices, grains, granola, you name it—if it was basic brown and unshapely, it was mentioned. For these types of food, you sometimes have to rely on external cues in order to make the food stand out. Many times I'll apply some color theory, using contrasting colors as the surface. Finely selected props will also help bring some much needed pizzazz to a dull subject.

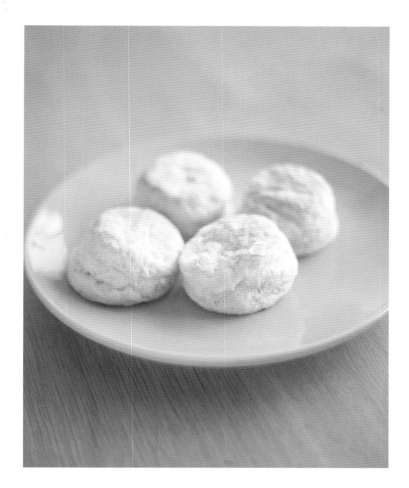

Although these homemade biscuits are flaky and delicious, putting them on a similarly colored plate and background sure ain't doing them any favors. The focus and exposure is accurate, but the biscuits still don't stand out the way I want them to.

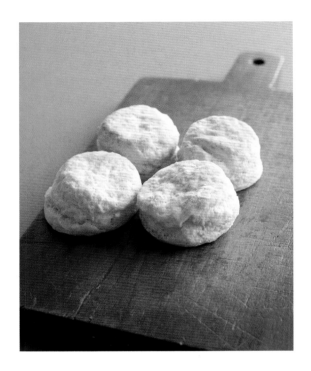

WINDOW

BISCUITS

LARGE FOAMCORE

CAMERA

Here's the same angle, same placement, and same lighting, but on a different surface and a wooden board. Notice how the biscuits now stand out? All they needed were a few simple changes in props.

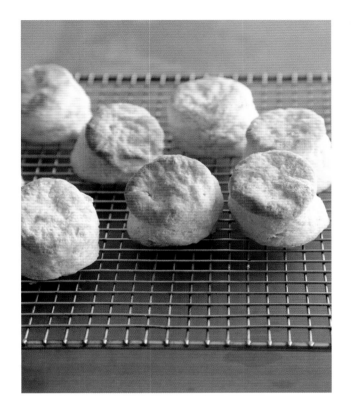

WINDOW

BISCUITS

LARGE
FOAMCORE

CAMERA

Who says everything needs to be plated? These same biscuits were beautiful on a cooling rack, and the dark gray surface and silver-colored rack provide a strong contrast.

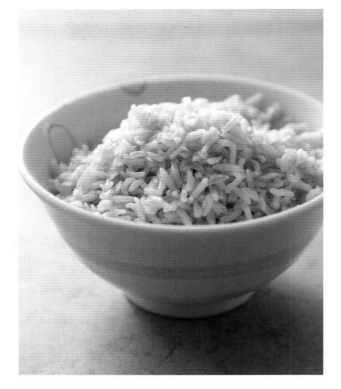

WINDOW

**BOWL OF
BROWN RICE**

**NO FILL
OR FOAMCORE
HERE**

CAMERA

Brown rice made the list a few times, but it doesn't have to be boring. Depending on the recipe and its ingredients, sometimes I just go close to show the food as detailed as possible. As simple propping and a simple surface will show, sometimes less is more.

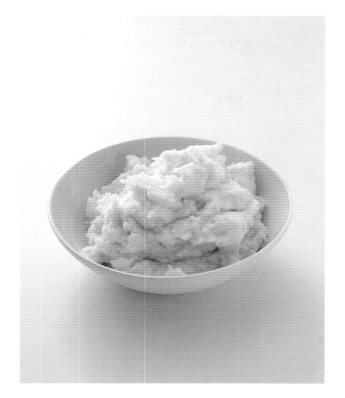

MASHED
POTATOES

NO FILL
OR FOAMCORE
HERE

CAMERA

And what about potatoes? Again,
a shapeless white blob of food.

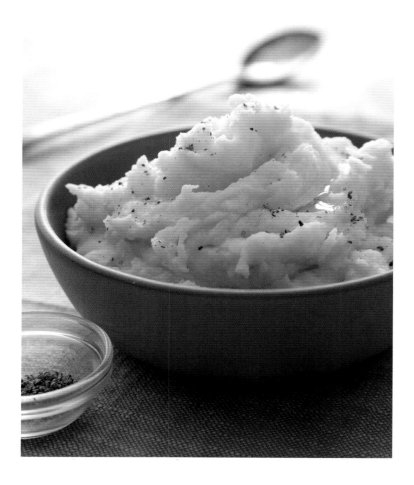

Okay, really, I love soft even lighting in food photography, but it doesn't always work too well for contrast when you have white food + white bowl + white surface. In this case I took the same food, added a darker bowl, got a little closer to the food, added some pepper and melted butter, and changed it significantly. Remember, props are your friends!

Here's the styled bowl of potatoes photographed from a wider angle. You can see how there's just one main light source (a big window with fabric over it), and no fill card was needed. The key to getting this shot is a tripod; you'd be surprised how little light you need to create a proper exposure.

WINDOW

PASTA

CAMERA

SMALL FOAMCORE

Another difficult item to style and photograph is pasta, but it needn't be. Again, selecting a bowl and background to contrast the pasta is key. And pasta is beautiful to begin with, provided you go easy on the plating and remember that less is more. Even if you've made a giant batch to feed a family of 12, you don't need to show a whole bunch to make your point.

This is a basic linguine with alfredo sauce. There is nothing remarkable here, but as long as the light doesn't overpower and wash out the dish, you're doing well. Inside this bowl is a little less than one serving—not much. The light is fine but the food looks a bit messy. Unfortunately, this recipe has no solid ingredients we can use to style, so in this case we're going with plan B.

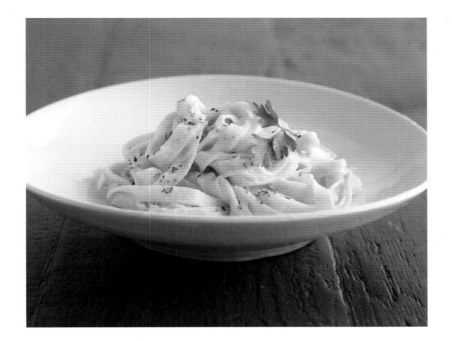

subject, in this case a shiny piece of meat. Although these highlights sometimes drive us crazy on other objects like glass, I find that with meat they give us shape, movement, and life that we like in an image.

I picked a big giant blob of meat, a roast, to show what I'm talking about when it comes to specular highlighting. Keep in mind that these might be advanced examples of how to control light, but the principles are the same and apply to steaks, sausages, meatloaves, roast chicken, you name it, because when you're photographing a brown hunk of anything, you need to accentuate whatever you can.

The recipe for this roast called for a searing before roasting. This is common with all sorts of meat dishes because it allows you to get some great tasting brown crusts before roasting or cooking. I'll photograph this process or even show the raw ingredients, in this case the vegetables. Why? Because I find beauty in these moments. Besides, who says you always have to show the final dish?

Without having much to work with, we went for a garnish of freshly cracked pepper and some herbs to style with. It's not much, but additions like these can sometimes make a world of a difference.

Let's talk about the dreaded meat shots, shall we? Next to soups, this tops the list of foods that cause people to struggle. With apologies to my vegetarian and vegan friends, meat is a hunk of, well, meat, and it's never inherently beautiful in the way an artichoke or pear is. It's dead, brown, and heavy, requiring us to rely on distinct visual cues to make it look its best. How do we do this? Through lighting and thoughtful preparation. In my experience I've relied on specular highlights to give it definition, shape, and texture. Simply stated, a specular highlight is a bright spot of light that appears on the

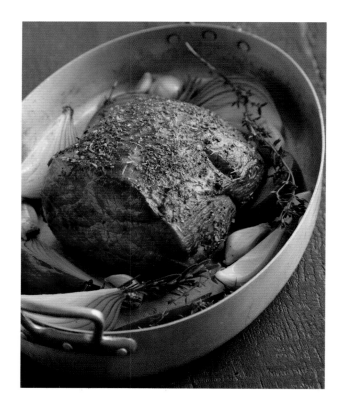

This roast has been seared
and placed back into the pan.
I happen to think the raw vegeta-
bles and herbs looked beautiful,
so I placed the entire dish so that
a window illuminated it on the
right side via sidelighting. Simple
and easy. See the white highlights
on the meat toward the back
right? Those are the types of
highlights I'm after.

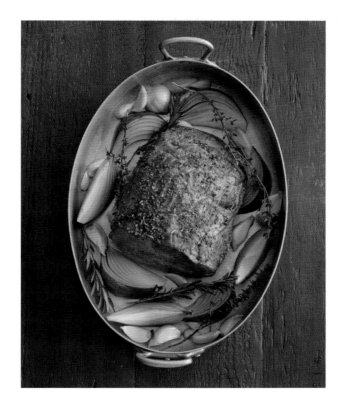

As an alternate I like to photograph from overhead, too. There are many moments where changing the angle can change everything, allowing for a much more graphic presentation of a dish. There's no right or wrong way to look at a dish.

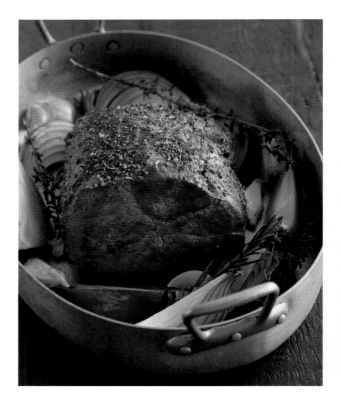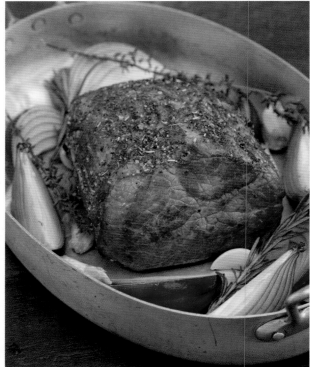

Here's an alternate view of the same seared-only roast with raw veggies. The image on the left side has the highlights I like, whereas the image on the right does not. Can you see what I mean by looking a little flatter, muddier, and duller? It has lost its sheen simply by blocking the light a little too much.

By now the roast has cooked, filling the house with delicious aromas. I really can't wait to eat, but first I need to photograph the roast! Luckily for me, meat has a short resting period in the cooking world, allowing it to reabsorb its juices so that they don't run out all over the cutting board. This is my moment to grab the shots I need, as meats like pork and beef have a tendency to oxidize, changing colors over time, as well as shrink as they reach room temperature. Because I like capturing real, edible food, this is the best time to take my shots. Keep in mind that this is just a rule of thumb: a slow-cooked pot roast covered in gravy is much more forgiving, for example.

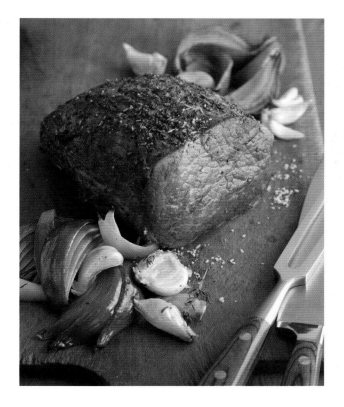

With my main light source to the right (a big window), my roast has rested and I've used the cooked onions and garlic as garnish. The highlights on the surface of the meat allow the eyes to see its moistness, freshness, and shape. And this angle also allows us to see some nice color variation from the top, which is textured with salt and pepper right down to the front of the roast, moist and ready to be sliced.

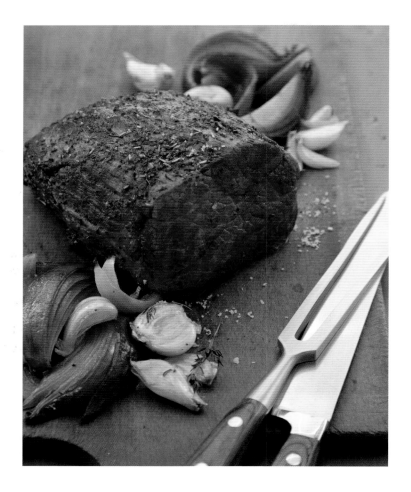

Here we have the same roast, but I blocked the window to show you how flat things can appear without directional light. Neither the window nor the roast moved; I only blocked the main light source. The result? A flat, shapeless piece of meat that still looks okay but lacks the dynamic qualities of the previous image. Keep these tips in mind when shooting meat.

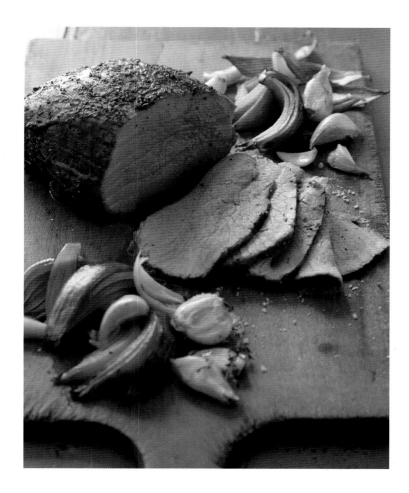

After a few minutes of resting, the roast was sliced. This really shows the inside color well and is my final shot. For this last image I actually moved the cutting board around so that the main light source was directly behind the meat, and I utilized a small fill card to bring in some light from the left. I then brought in a small piece of black foam core to darken the green surface just a bit—I like the variation in color and light. After everything was in place and the photo was made, it was time to eat!

WINDOW

BLACK FOAMCORE

COOKED SLICED ROAST

CAMERA

Here's an overhead glance of the setup. You can see that food photography doesn't require tons of light or gear and works well with what you have on hand. I like that!

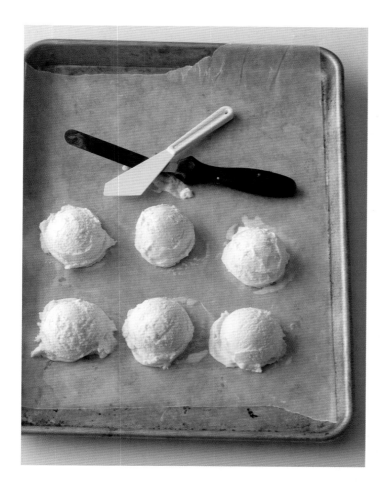

And how about something sweet? A few wrote asking how to photograph ice cream without it melting. I happen to think that it's okay to see it with a little melt—that's what it does. But because timing is everything, here's a nifty trick we often do in the studio when it comes to scooping ice cream.

Several scoops are created and placed on a cookie sheet that's been kept in the freezer for a while. Place the scoops on the already chilled cookie sheet and place it back into the freezer. Work fast! When you're ready for your shot, take a scoop out, place it into your cup or bowl, top with whatever it is you're using, and photograph. It's a simple trick, and you can still eat your ice cream!

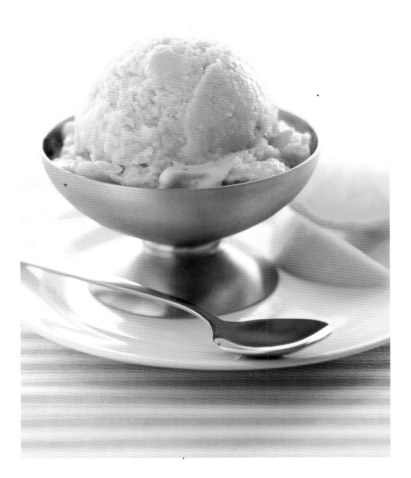

Lastly, a few left comments about cocktails and drinks and the difficulty in photographing them. I actually think they're some of the easiest things to photograph considering they're just liquid. Again, there are reflections at the top of the glass to contend with but I usually remedy that by photographing directly into the glass like the examples here show. And if a drink has ice in it, even better, as ice cubes offer built-in shape with lots of light variation. In my case, I try to backlight as much as possible to show the color of the cocktail. Of course, in a dark bar this isn't always possible. And what happens when we move the light to the side? We get what is still an agreeable photo, but it has none of the light coming through the glass or drink. It's all a matter of preference and what you think looks best.

Same angle, same drinks, same glasses. But changing the direction of the lighting can make a huge difference when it comes to the colors of a drink. I prefer seeing a well-illuminated Old Fashioned (center), but I also prefer seeing more of the yellow Lemon Drop's color when lit from the side.

Learning and Accepting When Things Are Good Enough

When I shoot food, I constantly hear my inner voice say to me, "Well, it is what it is." No matter how much you style or arrange certain foods, they are what they are, and sometimes that must be good enough. You cannot make a casserole look like beautiful French macaroons, no matter how hard you try. When I photograph difficult foods, I must learn to be happy with a correct exposure, decent propping, good lighting, and just let it be. There's always tomorrow!

Although I used natural light for all the shots in this chapter, remember that your lighting can come from a window, a lamp, a strobe, whatever! Light is light, and the techniques I hope you've learned from this chapter will apply to almost any light source.

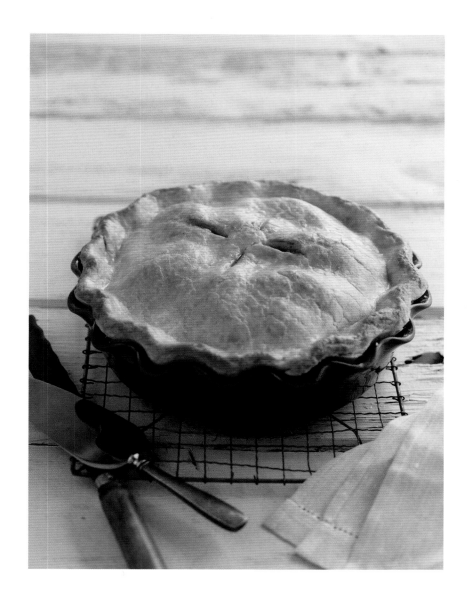

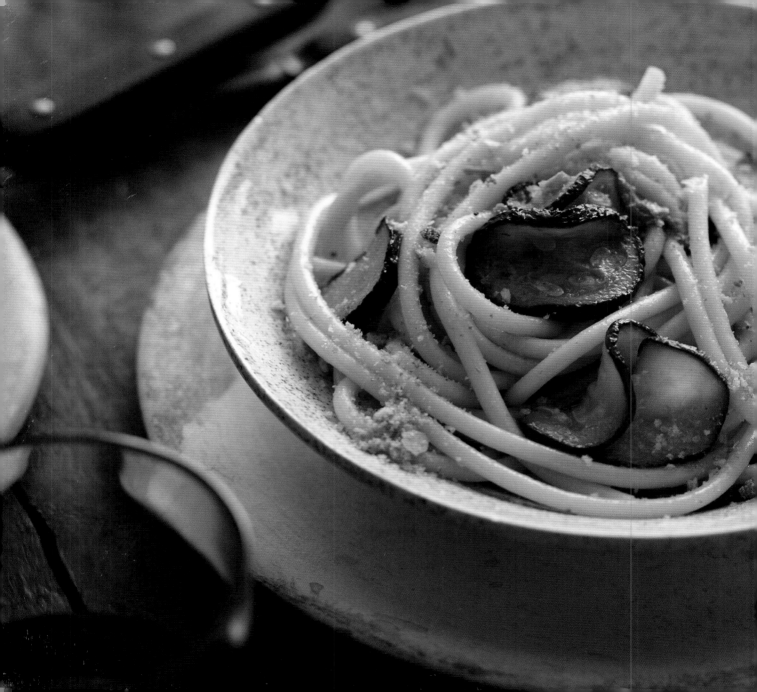

Chapter 15: Help! I'm Photographing My Dinner!

Even dinner at home can be a great moment for photography

So far we've talked about how to control variables in a studio or home and how to shoot in a restaurant, but what about those of us who need to get a photo of our food and then have dinner on the table immediately? What if you don't have those extra 30 minutes to play around and style? Not to worry! Trust me, it can be done. You just have to work backward so that everything is ready to go. In fact, the last thing you'll have to do before eating is to quickly snap a photo. Here's a process that can work for you.

Mise en Place

The French phrase for "putting in place" may refer to having ingredients lined up and ready to cook, but it can also apply to the photographic process. Having your camera fully charged with ample space on the memory card, a quick stand-in for framing, and lighting complete and set ready will help you get the quickest photo so that you can get to the best part—the eating!

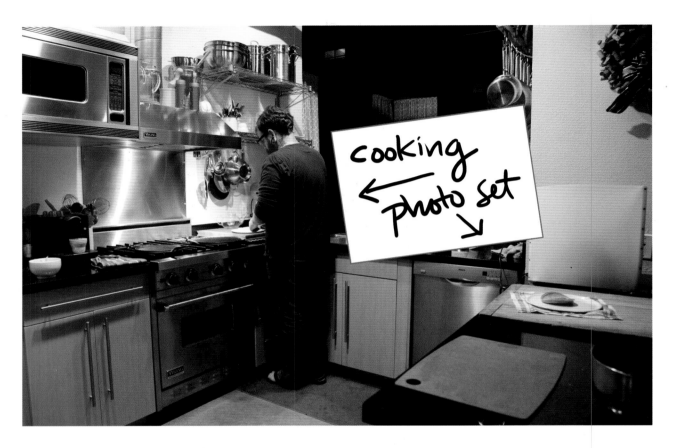

Even as dinner is cooking, the photo set is ready to go so that dinner can be served with minimal interruption.

While Prepping Dinner, Save Some Extra!

As you cook dinner, borrow a food stylist's trick and save a few of the ingredients for garnish and plating. Making pasta sauce with fresh basil? Save a few leaves for the photo. Having tacos for dinner? Save a few of the best looking toppings off to the side to be placed on the final dish. It's easy once you get the hang of it, and best of all everything is edible.

Dinner Cooks, Check Your Camera

While dinner cooks, it's time to check your camera. Make sure you have space on your memory card, a full battery charge, and that everything is in place.

Set up the Shot

While dinner is still sizzling or baking away, set up your shot. I'll use my kitchen counter only a few feet away from the stove, place a piece of paper or fabric down, and if I'm shooting after dark I'll bring in a light or lamp and a piece of foam core or a reflector.

Use a Stand-in

I'll grab an extra plate and do a few test shots before my food is ready. This helps me position my light direction and fill card so that I'm ready. I don't need food on the plate either, and sometimes a wadded up paper towel makes a decent stand-in.

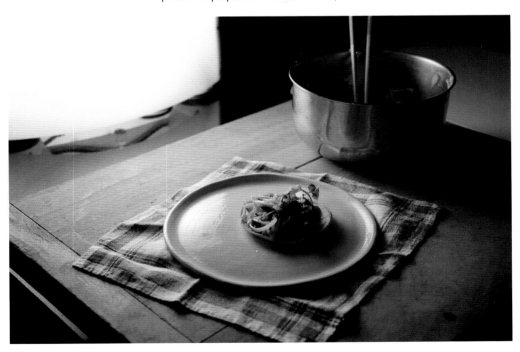

Finish Cooking Dinner

With lighting set, I can now go back to cooking dinner. Depending on what you're cooking (a quick 10-minute sauté or baking for an hour), you'll need to adjust the time that you set up your shot in the previous steps.

Plate It! Shoot It!

Remember, the goal is to photograph what you're making for dinner, and if it just happens to be magazine-cover worthy, then all the better! But because you've taken the time to set up your set and shot earlier, this should be a relatively quick step. Don't forget the garnish, and when those hungry eyes of family members start staring you down, just remind them that you won't be long.

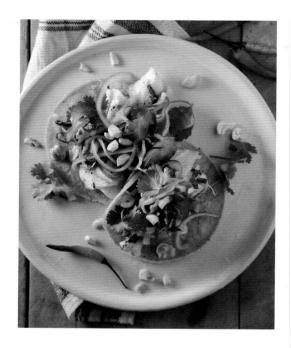

Because everything was ready and set, it only took a few seconds to snap this image of my Thailand-Meets-Mexico Fish Tacos.

Sit Down and Eat!

I don't really have to tell you about this part, right?

Strike Your Kitchen Set Later

Because I keep things to a minimum when it comes to shooting dinner, all I have to do is put a light and some paper away as I clean the kitchen. Or I just announce that no one gets dessert unless they help.

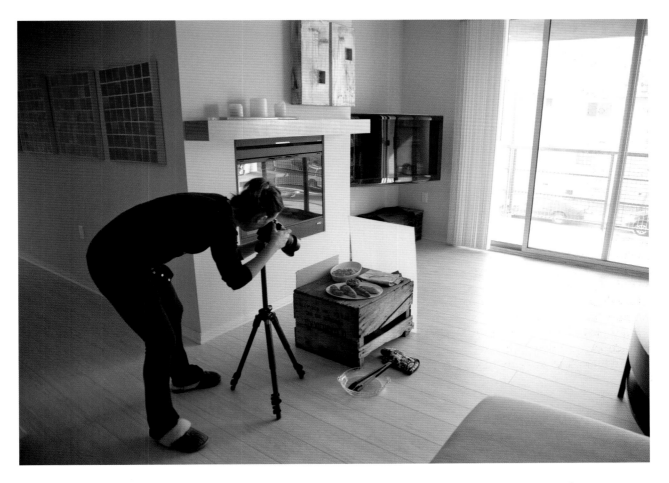

My best friend, the lovely Gaby Dalkin of the blog What's Gaby Cooking, will make dinner early, photograph it when there's a lot of afternoon light, then put it in the fridge for dinner. Now that's planning!

Index

Note: Page numbers with "f" denote figures; "b" boxes.